Keepers

of the

Spirit

Keepers of the Spirit

Stories of Nature and Humankind

Chris Rainier

Photographer

Paul Berry

Editor

Foreword
Marianne Fulton

Introduction
Oren Lyons

Beyond Words Publishing, Inc.

Beyond Words Publishing, Inc.
13950 NW Pumpkin Ridge Road
Hillsboro, Oregon 97124 USA
503-647-5109

The EarthSong Collection: Books that plant trees,
save eagles, and celebrate life on Earth

A Circle of Nations
Light on the Land
Keepers of the Spirit
Moloka'i: An Island in Time
Quiet Pride
The American Eagle
Wisdomkeepers
Within a Rainbowed Sea

Library of Congress Cataloging-in-Publication Data

Keepers of the spirit : Stories of nature and humankind / Chris
 Rainier, photographer; Paul Berry, editor; Marianne Fulton,
 foreword.
 p. cm. 76-0
 ISBN 0-941831-76-0 : $50.00
 1. Human ecology—Pictorial works. 2. Ethnology—Pictorial works.
 3. Human ecology—Religious aspects. I. Rainier, Chris.
 II. Berry, Paul.
 Gf46.K44 1993
 304.2—dc20 93-22843
 CIP

"The Ferry to the Far Shore" excerpted from *Encountering God: A Spiritual Journey from Bozeman to Banaras*.
(Boston, Mass.: Beacon Press.) Copyright © 1993 by Diana L. Eck. Reprinted by permission of Diana L. Eck.

"Inner Peace, Universal Responsibility" excerpted from *The Dalai Lama: A Policy of Kindness*, compiled and edited by
Sidney Piburn. (Ithaca, N. Y.: SnowLion Publications.) Copyright ©1990 by Sidney Piburn. Reprinted by permission of
publisher.

"Sacred Connections to the Land" excerpted from *Wisdom of the Elders*. (New York: Bantam Books.) Copyright © 1992 by David
Suzuki and Peter Knutson. Reprinted by permission of David Suzuki.

Dedication

To Priaulx—for showing me the pathway

To Ansel—for his insight and courage, which inspired and
changed my life

To my family: Peter, Joan, and my brother—
for their love and support

Design: Principia Graphica
Printing: Dynagraphics
Binding: Roswell Binding
Printed in the United States of America
This book is printed on recycled paper.
Distributed to the book trade by Publishers Group West

CONTENTS

A speech on behalf of the Indigenous Nations and Peoples of the Great Turtle Island delivered to the United Nations General Assembly in New York, December 10, 1992

This proclamation brings hope, inspiration, and renewed dedication to our quest for self-determination, justice, freedom, and peace in our homelands and territories.

Indeed, this quest is renewal of what we enjoyed before the coming of our white brothers from across the sea. We lived contentedly under the *Guyanasha Gonah*, the Great Law of Peace.

We were instructed to create societies based upon the principles of peace, equity (justice), and the power of the good minds.

Our societies are based upon great democratic principles of authority in the people and equal responsibility for men and women.

This was a way of life across the Great Turtle Island, and the freedom with respect was everywhere. Our leaders were instructed to be men with vision, to make every decision on behalf of the seventh generation to come, to have compassion and love for those generations yet unborn.

We were instructed to give thanks for all that sustains us, thus we created great ceremonies of thanksgiving for the life-giving forces of the natural world, that as long as we carried out our ceremonies, life would continue.

We were told that the seed is our law. Indeed, it is the Law of Life—it is the Law of Regeneration. Within the seed is the mysterious and spiritual force of life and creation.

Our mothers nurture and guard that seed, and we respect and love them for it, just as we love *Enenohah*, Mother Earth, for the same spiritual work and mystery.

We were instructed to be generous and to share equally with our brothers and sisters so that all may be content.

We were instructed to respect and love our elders, to serve them in their declining years, to cherish one another.

We were instructed to love our children, indeed, to love all children. We were told that there would come a time when the parents would fail this obligation, and we could judge the decline of humanity by how we treat our children.

We were told that there would come a time when the world would be covered with smoke and that it would take our elders and children. It was difficult to comprehend at the time, but today we have but to walk outside to experience it.

We were told that there would come a time when we could not find clean water to wash ourselves, to cook our food or make our medicines, or even to drink, and that there would be disease and great suffering. Today we can see this, and we peer into the future with great apprehension.

We were told that there would come a time when tending our gardens we will pull up our plants and the vines will be empty. Our precious seed will begin to disappear.

We were instructed that we would see a time when young men would stride angrily back and forth in front of their chiefs in defiance and confusion.

This you have brought to our lands. The catastrophes we have suffered at the hands of our brothers from across the sea were unremitting and inexcusable. It crushed our peoples and nations down through the past five centuries.

You brought us disease and death and the idea of Christian domination over heathens, pagans, and savages. Our lands were declared vacant by papal bulls that you created to justify the pillaging of our lands. We were systematically stripped of our resources, religions, and dignity. Indeed, we became resources of labor for gold mines and cane fields. Life for us was unspeakably cruel. Our black and dark-skinned brothers and sisters were brought here from distant lands to share our misery, suffering, and death. Yet we survived.

I am a manifestation of the spirit of our peoples and our will to survive. Beside me stands my spiritual brother, the Wolf; we are alike in the Western mind—hated, admired, and still a mystery to you. Yet we are not defeated.

So then what is the message I bring to you today? Is it our common future?

It seems we are living in the time of prophecies, a time of definitions and decisions. We are the generation with the responsibility and option to choose the path of Life with a future for our children or the path that defies the Law of Regeneration.

Even though you are in your boat and I am in my canoe, we share the same river of life. What befalls me, downstream our children will pay for—our selfishness, greed, and lack of vision.

Five hundred years ago you came to our pristine lands of great forests, rolling plains, and springs. We and our lands have suffered in your quest for "God, Glory, and Gold." But we have survived.

Can we survive another five hundred years of "sustainable development"? I don't think so. Reality and the Natural Law will prevail—the Law of the Seed and Regeneration.

We can still alter our course; it is not too late. We still have options. We need the courage to change our values to regenerate the family.

We must join hands with the rest of creation and speak of common sense, responsibility, brotherhood, and peace. We must understand that the law is the Seed, and only as true "partners" can we survive.

Dahnayto. (Now I am finished.)

Chief Oren R. Lyons
Faithkeeper, Haudenosaunee (People of the Longhouse)
American Indian Elder, Six Nations Iroquois Confederacy

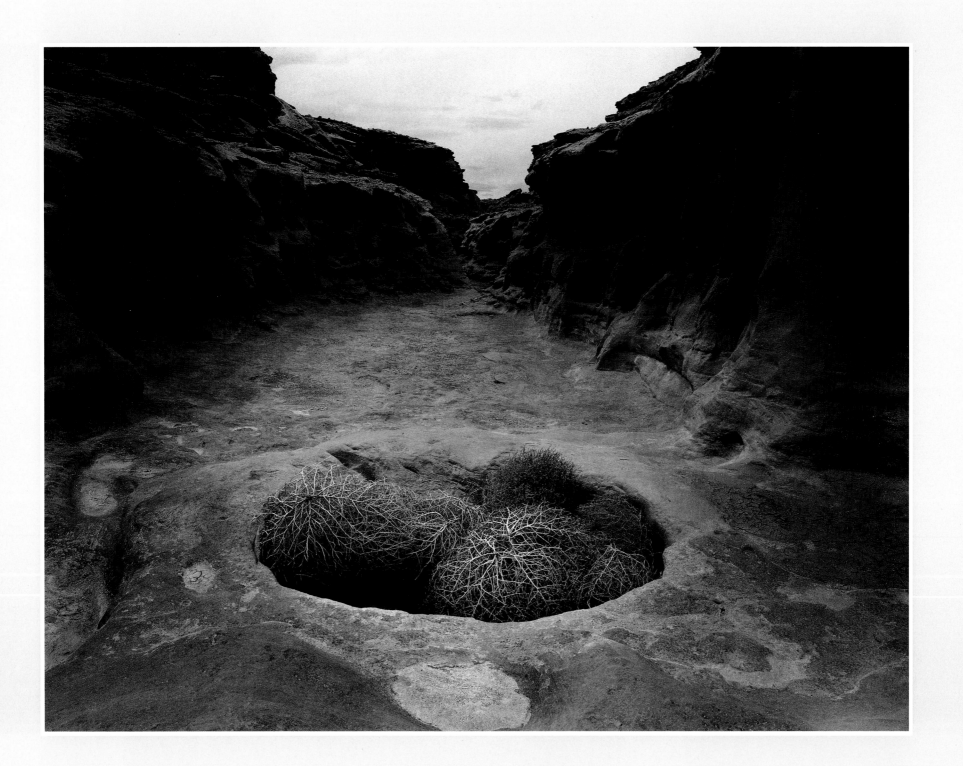

INTRODUCTION

Photography is always about time: time past, time caught, time lost. Chris Rainier's photography seems to encapsulate a timeless, ageless moment—each a perfect pearl on the strand of history. But this is not quite right. Transition, change, and human passion permeate the photographs. Though stilled on the page, they speak of a human need. The need, passed through hundreds of generations, is the true ageless presence.

To be truly without age, the great temples and carvings would have to pass through time unscarred. What Rainier shows instead is the encroachment of roots over shrines and totems, some beginning to sprout new life themselves, overtaken by the forest. The great facade of the temple of Angkor Wat is rent asunder—as if a dark lightning had revealed its ultimate vulnerability. Other rites of passage are echoed throughout the work: death is a seamless passage into another part of life. In New Guinea, a man holding the specially preserved corpse of a village elder acknowledges the wisdom and power of the deceased and, in turn, is consoled by the continuing presence.

Turning the pages, one sees that each place has its own language and is translated differently by the photographer: Sri Lanka is quite different from the Queen Charlotte Islands. The thunderous austerity of Ladakh is especially striking. Stark profiles rise above the dry wastes; prayer flags flying remind us that humanity's spirit is nourished in all places. The continuity of belief cannot be captured by momentary existence. A white temple glistens in the moving palms. We know that this image is enhanced by the photographer's skill of interpretation, but on the other hand, anyone who has ever seen a gleaming white dome knows that one's eye and mind are not capable of comprehending the brilliance.

Chris Rainier's photographs are at once a forceful yet tender embrace of a changing world. Rainier is not naive; his work for humanitarian organizations on the front lines of starvation and civil war do not allow him that luxury. That this is not a collection of landscape photographs is significant. Stone will pass away. Wood will be consumed quickly. But people endure and their strength of will is belief incarnate.

That Rainier holds these places and people in reverence is beyond doubt, but there is more here than the exquisite textural rendering of stone and skin. There are questions asked, and the world must answer. Only time will tell.

Marianne Fulton
Chief Curator, George Eastman House

Page 8: In this solitary place in the Southwestern desert,
I long ago discovered the opening of a pathway.
Now, years and continents later, I find that this path
has led me deeper into nature and closer
to those who would keep its spirit.

The myth of the photographer's life embodies a rich fantasy. In the myth, the photographer appears in a long-sleeved khaki shirt, with canisters of film on a tattered belt, and the world-weary look of someone strung out from crossing too many time zones. Life supposedly consists of loneliness assuaged by casual romances and alcohol, the ecstatic moments in the darkroom, a wordless grasp of everything you see, and cameras hanging forever in multiples around your neck. The myth is that you capture lightning in a bottle and remain unfettered by normal human burdens.

In reality, photography has little to do with the myth, and it carries lots of submerged costs. Like music, it takes long years of working at a discipline; you work at learning the possibilities of all the equipment, and you work at learning about yourself, yourself as the first viewer of any of your own photographs. Without curiosity, a compassion for the human condition, and something different to express, the photographer's eye is blind. Eventually you also begin to learn some of the unavoidable costs: emotional (friendships unattended and companionship forgone), physical (malaria, dysentery, and nightmares of war), intellectual (learning from short-term failures the costs of long-term successes). Finally, though I am still relatively young, I have come to appreciate the value of discipline, again as musicians do, with endless practice leaving you awaiting that moment when you can produce art.

Photography has a way of confirming the need to learn from failure. Having spent all the effort to get there, sometimes you learn that you simply were not meant to get the image you were after at that time or place. In the heat of civil war in Somalia, for example, there were the two rolls of film that didn't wind as I ducked sniper fire. I still dream of those lost pictures. On a grander scale, there is the story of Edward Curtis, the famous photographer of Indians in the turn-of-the-century American West. He had six months of work captured on dry film plates when his donkey stumbled on a mountain trail and fell, smashing the plates. He did not pause to feel sorry for himself. He simply turned around, and with his remaining plates, went back to start over. Intuitively he grasped the value of documenting the last of a vanishing culture, and that for me casts him as a hero.

Photographers inevitably face a variety of artistic cul-de-sacs. They take artistic chances that require the investment of months or years, and then sometimes they lose. Sometimes they end up working for a lifetime in the hope of getting one quintessential photograph. Having fallen under the influence of Georgia O'Keeffe, Ansel Adams at one point began photographing the Christian crosses of the Southwestern desert—in graveyards, on churches, wherever he could find them. While many of the photos met with success, some from the graveyards were never printed because Adams was sure that they did not meet his previsualization, i.e., they would not create the emotional response he sought. In one case, the famous photo known as "Clearing Winter Storm," it took him over twenty years of trying to get just the image he wanted from Yosemite. The photo we now know finally matched what he had previsioned for all those years.

I spent five years working with Ansel Adams, and then I spent several years struggling to escape from the shadow of his style. I am left with a number of valuable influences from Adams, however, and among them is a philosophy of previsualization. I go out into the field looking for pictures that say, "Here is an important part of the quest." For example, in going to India, I try to avoid the chaos and instead look for what is there spiritually. While there is horror and poverty in abundance that can find its way to the lens of the camera, I search for those moments in the midst of it that affirm the dignity of the human spirit.

I usually begin a foreign assignment having consciously avoided Western information about the place, relying instead on what the people and the place say to me. The absence of a heavy overlay of cognitive preconceptions seems to leave the way open, for regardless of place, culture, or social constraints, I am after primary human experiences. For me, photography requires an approach from the heart, a nonverbal extension of myself to others that seems to allow me near my subjects naturally, without manipulation. Through practice, I have learned the value of slowing to discover the rhythm of what I see, and the satisfaction of treating people and places with respect.

It may serve readers better to approach the photographs in this book as a visual diary of the places I have found where the echoes of spirits still dwell. Some ask, why not the Pyramids, Delphi, the Aztec ruins? Because I have seen these places, and either there the spirits have vanished, or there they simply did not speak to me.

My photography allows me to speak of internal visions and emotions beyond words. For me, and perhaps for those who see it, it can also provide experiences beyond cultural stereotypes, glimpses of places at the edge of imagination. It is in these experiences that life for me holds a balance between the fearful darkness and the fragile clear light of inner peace.

Tennyson says in his poem "Ulysses," "I am part of all that I have met." Perhaps the fates have made sure that what I have met is a little different. My grandfather was an explorer in Africa and South America in the early 1900s, writing a book that eventually became a Hollywood movie about an emerald mine in the jungles of Colombia. My father grew up in this same environment until he was twelve. When his father was called to World War II, he helped to manage the ranch for a while, and then at age sixteen he forged his father's signature and went off to become a fighter pilot in the Royal Air Force in North Africa. In turn, I grew up submerged in the tales of these men, playing with the children of Aborigines in Australia and of the Masai in Kenya. In my mid-teens in London, I became close to my great-aunt Priaulx, a respected contemporary composer. Among her close friends were artists such as Benjamin Britten, Henry Moore, and Yehudi Menuhin, and inevitably I received the message that life is art. I learned as well that an artist ought to stretch beyond what is understood, and in doing so, create questions that may lead to comprehending more.

After a year of university, I felt the urge to live with indigenous people, and having been born in Canada, I found my way to a

place on the Arctic Ocean in the Northwest Territories where I lived with a group of Inuit for months. For others it might seem an odd thing to do, but there was no wringing of hands in my family. I had been raised with books and tales of adventure, or perhaps it was simply a matter of a gene that favors wandering. Whatever the cause, I have found myself a curious pilgrim, a pilgrim who needs no explanation for the journey.

Because I grew up constantly moving, I am given to studying human patterns in the hope of discovering what they can tell me. The work has taken me to all seven continents, so in a sense the planet is both my work and my home. In exploring, I have come to realize that my own culture lacks any significant sense of the spiritual quest, the journey, and so I travel, looking as I go. Beauty, tranquillity, horror—they are all there waiting to be experienced, and I journey as deep into the mysteries of each as I dare.

Photographers inevitably must address the issue of whether they are exploiting the subjects of their photographs. The issue poses moral questions for which answers do not come easily. Ansel Adams had to address the experience of floods of people arriving at Yosemite after seeing his photographs of it. Mary Ellen Mark, photographing the homeless and destitute in America and India, has had to confront the same question: Am I exploiting this situation for my own gain, or am I conveying the plight of these people?

At this point in my life, I have answered the question in this way: Yes, I am guilty of being only an observer. I am not a relief worker delivering people from suffering. I am guilty of only passing through. Oh, occasionally I stop—once to give blood in a war zone where it was needed—but essentially I am a storyteller in transit.

There is another side to the question of conscience, for beyond being an observer, I try to capture a moment in life and become a messenger of the human condition. In the distant jungles of New Guinea, I saw a native hack off the prow of his ritual canoe with a stone ax. Outsiders are extremely rare in this jungle, perhaps two dozen having come since the death there of Michael Rockefeller in 1962. But here was a native willing to sacrifice the wood-carved bow of his sacred tribal canoe in exchange for a steel ax from a stranger from the outside. It was an age-old economic exchange, one man's spiritual past being traded for another's insignificant hardware. It was a picture worth capturing, a message worth carrying to those who would trade axes. There was no way for the native to know he was selling an irreplaceable piece of his own identity, allowing himself to be homogenized into Western civilization.

If the canoe of civilization appears nearly full and in danger of sinking, I will at least have borne the message of the condition of its people. And I feel that I will have accomplished something else, for I will have documented humans living with a rich array of gods, spirits, and magic, in a balance with Earth and its mysteries. From the primal beauty of Eden in New Guinea to the empty landscapes of Easter Island, I want to make sure that we all can see the range of possibilities we have with nature.

With my photographs, I hope to show the past in the present and become part of the process of preserving life for the future.

As our television sets carry us boldly about the world, and as the chainsaws fell the last trees that hide the lost peoples, we lose an essential mystery, and with it, the wisdom that may lie there. If we would be citizens of the world, then we must do all we can to ensure the survival of that world. As only one form of life on Earth, we must keep our humility and finally honor life itself. Once the fragile umbilical cord to our primeval past has been severed, we will find ourselves truly alone, without purpose, adrift in a vast sea of space with nowhere to go.

13

Chris Rainier
Aspen, Colorado

The City of Light

Varanasi, India

Diana L. Eck

Banaras [or Varanasi] is a city famous for its cremation grounds. Manikarnika Ghat, the principal cremation ground, was once outside the city to the south, as is appropriate in a culture that is concerned with purity; everything associated with death is considered impure and should not normally be mixed in with the rest of life. As Banaras grew, however, it stretched out along the Ganges to the south and gradually surrounded Manikarnika. More important, the sacred city embraced and sanctified death, not just geographically, but spiritually. In Banaras, the cremation ground is holy, for it is a place where people come to die in the hope of crossing over to the "far shore" of this worldly life. "Death in Kashi is liberation," they say. So the elderly and the infirm come to Banaras to die. I never spent an afternoon in the heart of the city without hearing the chanting of a funeral party on its way to the cremation grounds.

One morning as I sat with Pandit-ji, translating Sanskrit on his front porch on Asi Road, a funeral procession came by carrying a corpse bound with cloth on a bamboo litter. They were headed for Manikarnika. It was nothing special. In Banaras, death is just part of the traffic. Pandit-ji smiled broadly and raised his eyebrows as he often did when he was about to impart a truth. He quoted to me from the Mahabharata: "What is a great wonder?" It was a passage where the righteous king Yudhisthira was being tested by a forest spirit. "What is a great wonder?" the spirit asked. "This is a great wonder," replied the wise Yudhisthira. "Every day we see people go to the city of death, and every day we go on thinking we will live forever." And so it is—a great wonder. We confront and yet do not confront death. We know that we will die. There is evidence every day in the lanes leading to Manikarnika. And yet we go on leading our lives as if it were not true. It is both a blessing and an astonishing feat of delusion.

In the United States, however, we do not see people go to the "city of death" on a daily basis. There is an acceleration of death as one's parents and their generation begin to die. We begin to read the obituary pages with regularity. Even so, our cultural "denial of death," as Ernst Becker has called it, is widespread. We do not confront daily death, at least when we are young, at least if we are lucky. When I first went to India, I was both young and lucky. Or was I? I had scarcely seen death. In India, however, I lived for the first time in a culture which did not attempt to cover up the pain and anguish of life and which did not deny the reality of death. Birth and growth, joy and celebration, disease, old age, and death— all of it is so visible, in fact overwhelming, in Banaras. Every aspect of life—beginning, fullness, ending—is present at an intense pitch.

In Banaras, death and suffering are visible in daily life as nowhere else in the world. Banaras is also the Lord Shiva's holy city, which Hindus speak of as the divine incarnation of Shiva's radiant light. As I came to Banaras, I asked over and over, How could this city, which displays the wares of death, be seen as so holy by Hindus? And its Lord, Shiva, seemed to elude description. He was called Vishvanatha, Lord of the Universe. Sometimes he was depicted as regal—adorned as the Lord of the Universe might be, with jewels, the scent of sandalwood, and the crescent moon as an

15

ornament in his hair. And yet the moment one expected him to be regal, said my Hindu friends, he would appear as a beggar, living on the cremation grounds, adorned with snakes as his ornaments, smeared with ashes.

Gradually in the face of this Shiva, and in this terrifying and bewildering city so closely associated with Shiva, I came to ask again the question of incarnation. How did I, in my mind's eye, *expect* the Divine to appear? Should God be pure, bright, clean, and probably Protestant—the resident glorious invisible Holy of the beautiful white churches of New England? Somehow I felt that Jesus the Christ would be more at home here, in Shiva's city. I began to see that it is precisely in this place, in the very presence of suffering and death, that Hindus affirm the abiding presence of Shiva and the certainty of passage to the far shore. If I could not see the point of the faith of Hindus in Banaras, I had missed the point of my own faith in the incarnate Christ, who is present not only in light and life, but also in suffering and death.

That death could not hold Jesus comes as no surprise to my Hindu friends. Death cannot hold anybody. As a Hindu friend once said to me, standing on the ghats in Banaras, looking down on the cremation ground, "You people think that death is the opposite of life, but we think of death as the opposite of birth." In the Hindu view, the soul's pilgrimage is a long one, and we are born time and time again. Krishna tells Arjuna in the Bhagavad Gita, "Death is certain for anyone born, and birth is certain for the dead; since the cycle is inevitable, you have no reason to grieve." The incarnation

and reincarnation of *atman*, the spirit or breath, is presupposed in the Hindu view. Birth and death are milestones, not the starting gate and finishing line of a single race.

It interests me that almost as soon as the ancient Indian sages had formulated the idea of rebirth, either in heaven or on Earth, they became restless with it. What disturbed those thinkers was not so much rebirth, but re-death. Being born over and over again was not so unappealing, but the prospect of dying over and over was deeply disturbing. The cycle of birth and death was not itself spiritually satisfying, and final liberation became the ultimate goal. Even for Hindus who presuppose that "death is certain for anyone born, and birth is certain for the dead," there is a yearning to cross over to the distant shore of freedom, to cross over "from death to death-lessness." The closer counterpart of the message of resurrection is *moksha*, liberation from the long trajectory of birth and death. Birth and death will end. We will cross the river of birth and death, and there will be ultimate transformation, especially in Banaras.

The city of light is a place with an infinite number of spiritual layers, an endless series of sensual impressions. Wherever your eye falls, whatever your ear hears, there lies something of spiritual significance. And whatever is true elsewhere in India is truer in Varanasi, for to be even a beggar here is to perform a spiritual function, and to give to a beggar is to ensure good karma on a more profound scale. I have found myself drawn here again and again, perhaps because more than anywhere else, I find in the city of light a silent, coiled intensity of spirit at work.

There are other forces at work here as well—so many that there is no way to explain what you find. There is, for example, no way to explain the cast of light that carries pure consciousness. There is no way to explain the power of belief that turns the river into a god. Belief here extends beyond comprehension, for it is linked to this place with a force and direction that permeates everything, that reaches beyond the limits of time. Here for millennia belief has moved humanity to the doorstep of eternity.

But here in the city of light you also find the shadow of darkness holding the powers of light and dark in an ancient equilibrium. In the city of light, darkness takes multiple forms: beggars, blind people, starving children, odors of incense competing with the smell of human death, brilliant torches of burning bodies in the night, and in the early morning, stray dogs waiting downstream for charred human remains to wash ashore.

Varanasi is a wild mixture of contradictions, the sum total of which works wonderfully well together on a spiritual scale, but on a material scale it leaves many unanswered questions. Away from the stillness of the Ganges, the city takes on a chaotic carnival atmosphere: cows wandering the streets, people celebrating the passing of those who came here to die, a daylong din from bells and horns and shouts, temples of Shiva filled with supplicants, people praying to holy trees, solitary pilgrims lost in meditation, local merchants striding along with briefcases in hand, the king of the untouchables—his flowing beard like a biblical prophet's—sitting high above the city gazing at the funeral pyres, hundreds of movie houses showing colorful soap operas, and street vendors hawking flowers, candles, incense, and religious paraphernalia. Every day you can find scholars congregated in tea shops, the faint harmony of the sitar, parades with lights and portable effigies, rickshaws carrying the lame through the jumble of cars, taxis, buses, and bicycles, and endless commerce in matters of the spirit. It is life at once absolutely spiritual and absolutely raw, stretching the spectrum from divinity to Dante's inferno.

Here nature has a different relationship with man. Along the mirrored surface of the river, the far shore sits in a white haze a mile away, but during the height of the monsoon, the entire city can flood. Whole temples are sometimes submerged as nature reasserts its control over what man has taken, and man accepts the river's force as the manifestation of divine energy. The Ganges makes it possible to grow rice in the countryside, and fish from the river feed the people. In contrast, many large chemical plants upstream dump pollutants into it, yet the river is still the municipal water supply.

And downstream, inevitably, the city dumps its waste into the Ganges as well. From a Western standpoint, the waters of the river present a quintessential irony. Those who would find in the river the presence of divine energy are willing to use it with tragic disregard for all the life that relies on the Ganges.

Still, from the very beginning the rivers of the ancient subcontinent have been sacred, especially the Ganges. Hindu beliefs rise from ancient animism intermingled with the most elusive of all religious conceptions—the link between human life and the forces of the universe. While Western man sees a single god, a god outside of nature, Hinduism has a vision of the divine joined in endless spiritual forms within nature. Earthly life remains as a temporal moment on a long spiritual journey. All forms of worship come back to the primary source, the spirit of life.

Each day a steady tide of people comes to be cleansed in the River of Heaven. Many take a small container of water to pour on a nearby phallic statue, then cleanse themselves and move on to the material concerns of the day. It is a ritual that has been followed for more than 2,500 years, and no amount of technological novelty or illusory progress has the power to change it. The Ganges remains a form of divine energy—the beginning, flow, and end that embodies the essence of Hinduism. And it is because of the Ganges and the fall of light on it that Varanasi is spiritually charged, alive with hope, and fixed on moving human life toward the light of pure consciousness.

Varanasi (or Banaras), on the sacred river Ganges, is considered the holiest of cities in India. It is the destination of pilgrims who come to cleanse themselves of impurities daily on the banks of the Ganges. For a Hindu to come and die in Varanasi is to be ensured of salvation and nirvana. These photographs were taken between 1987 and 1992.

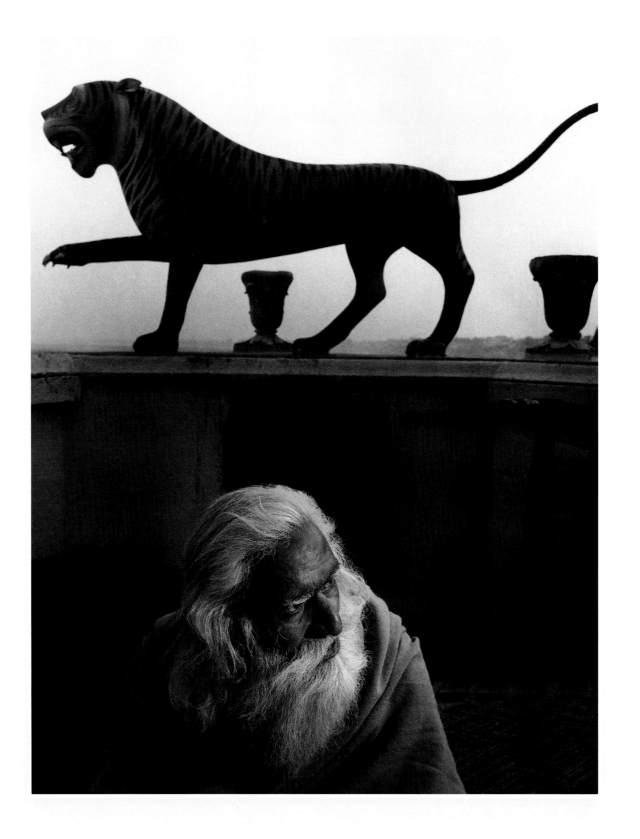

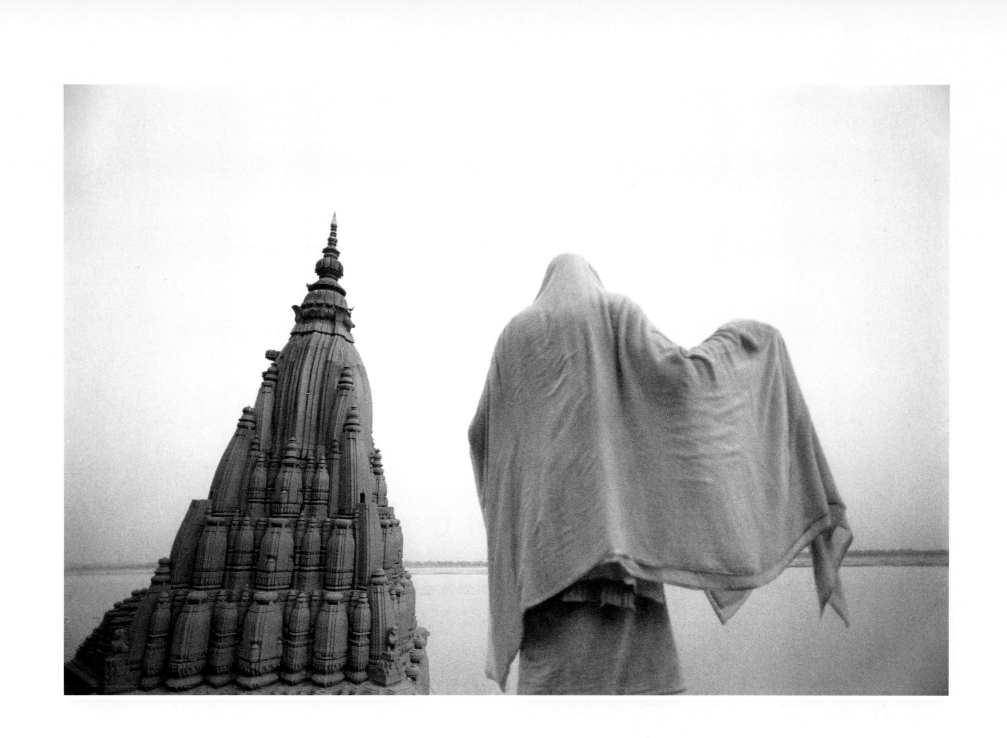

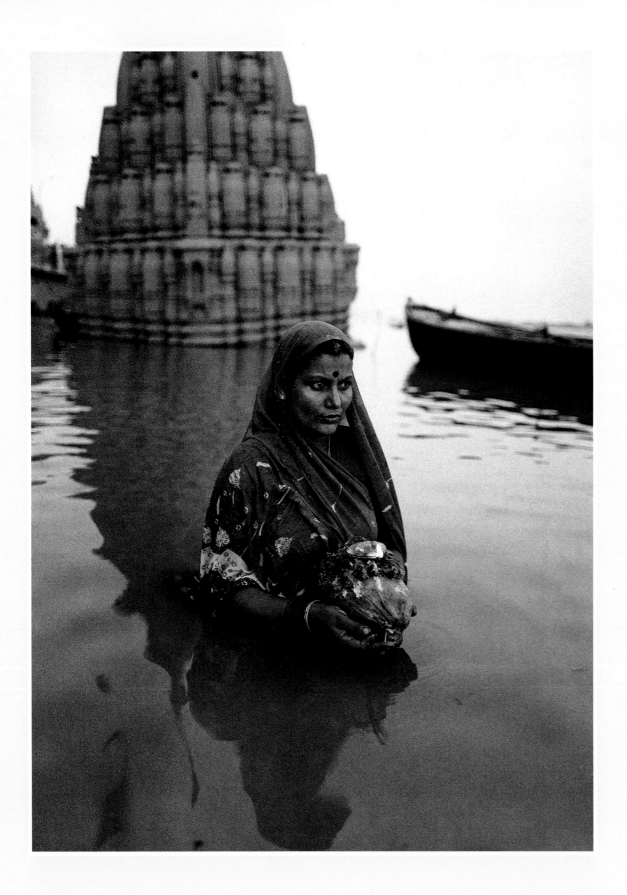

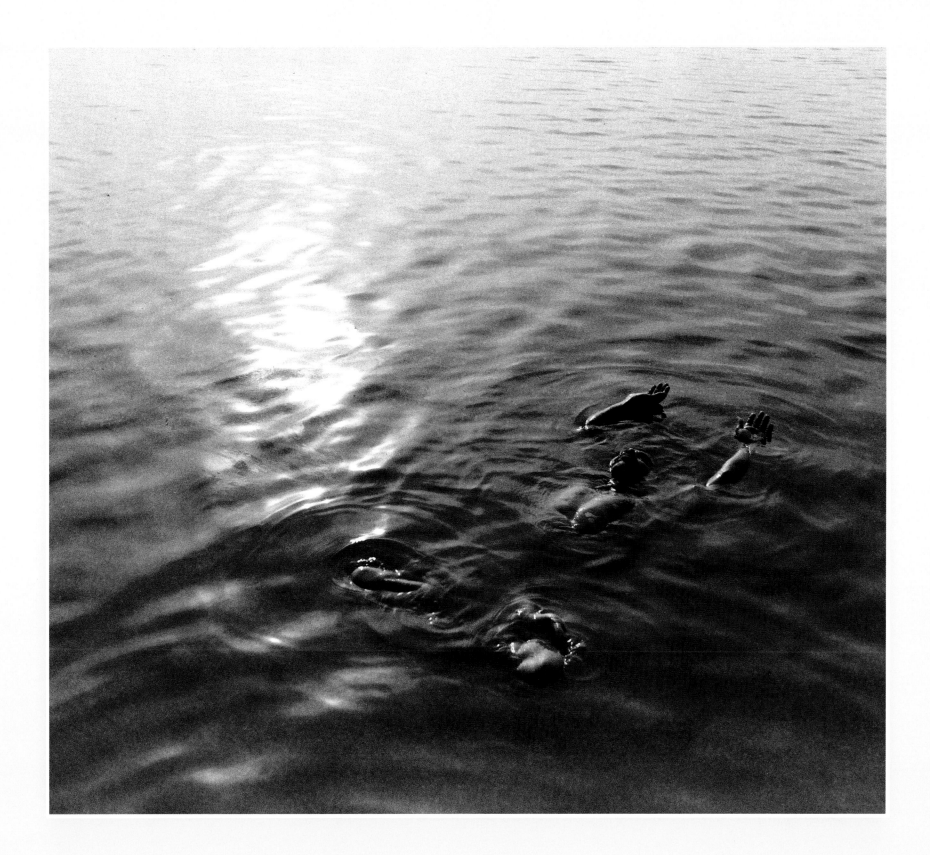

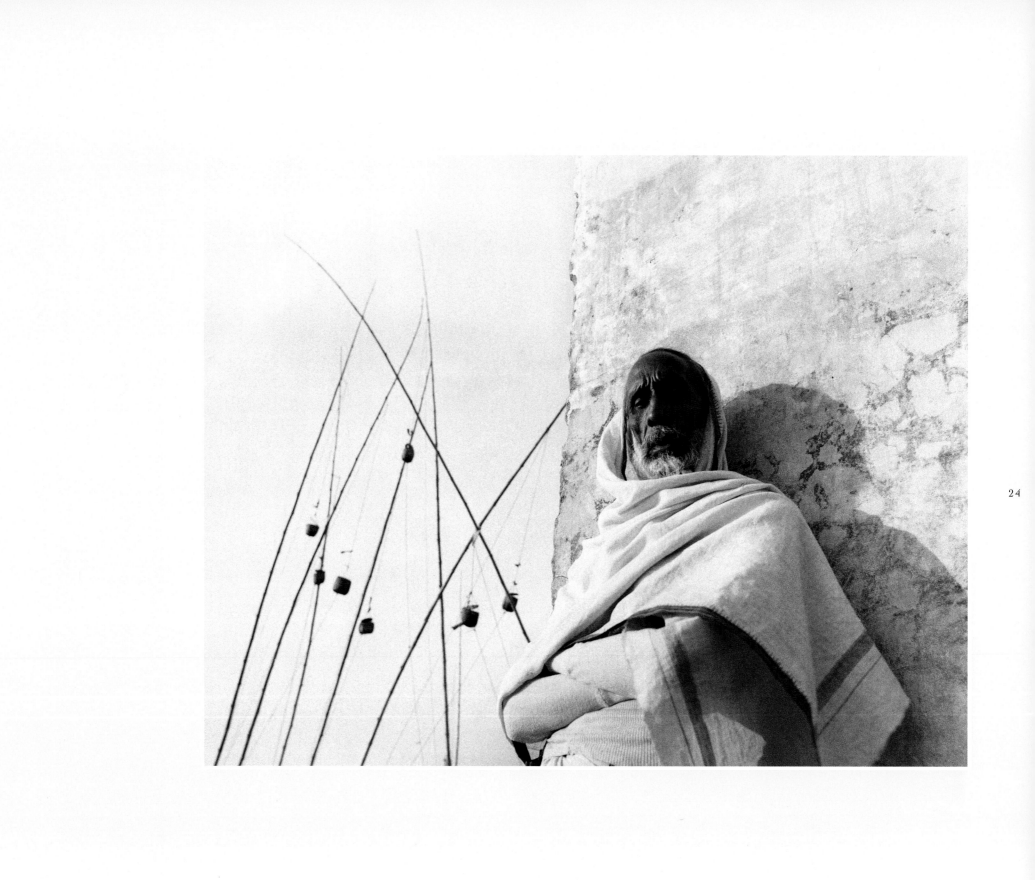

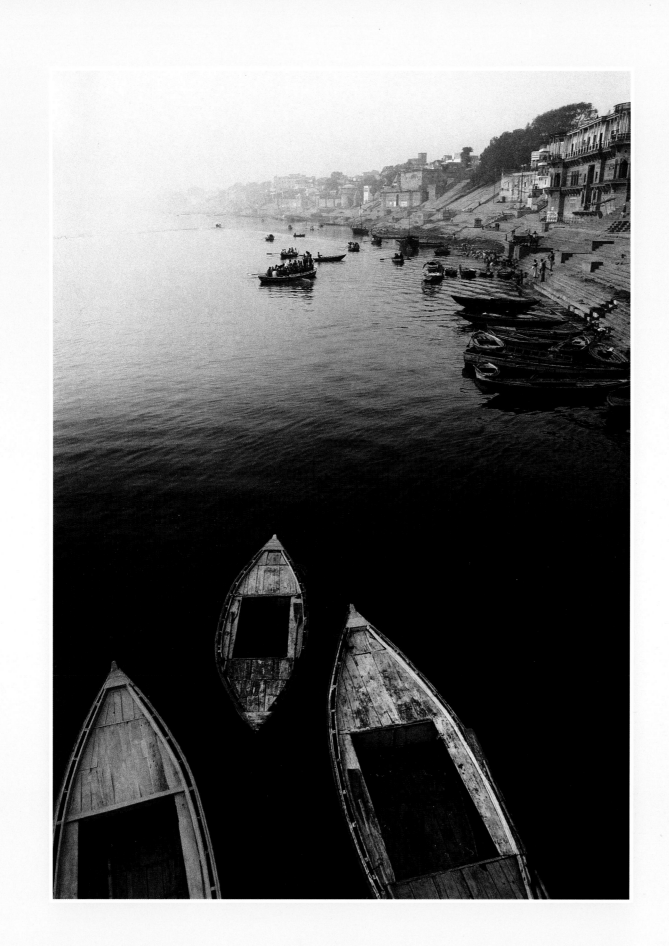

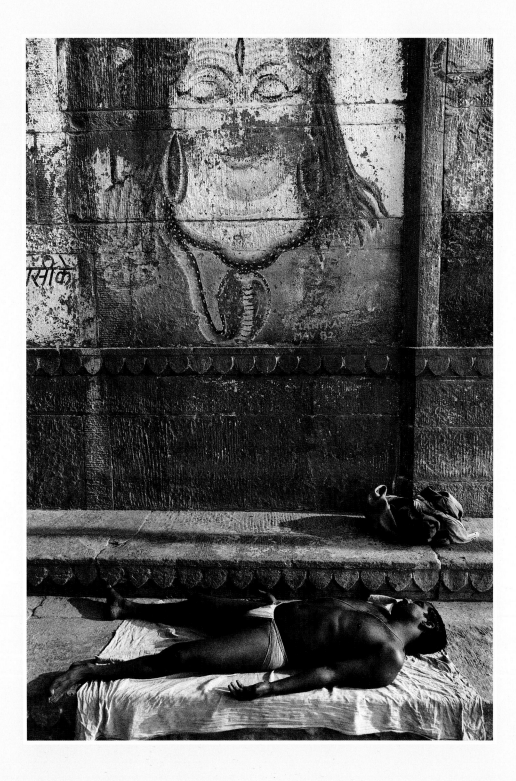

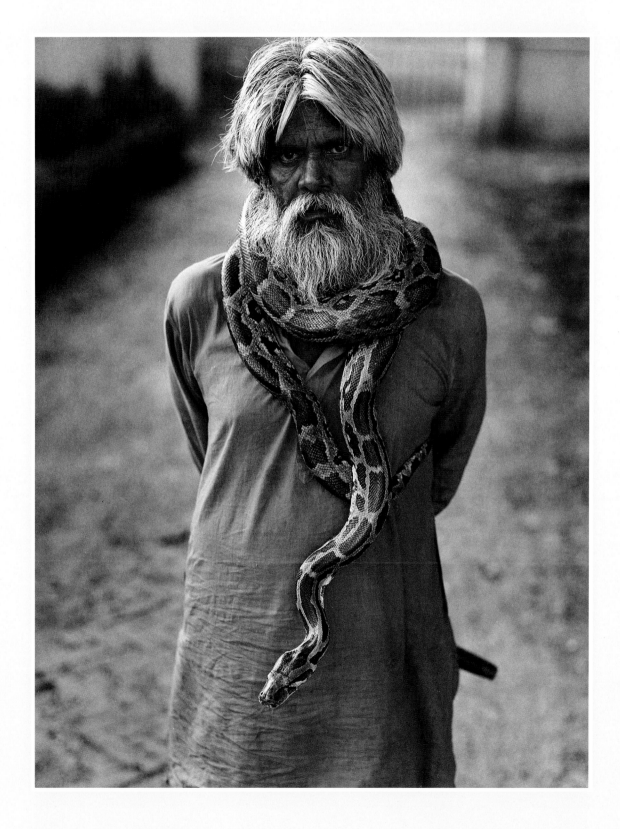

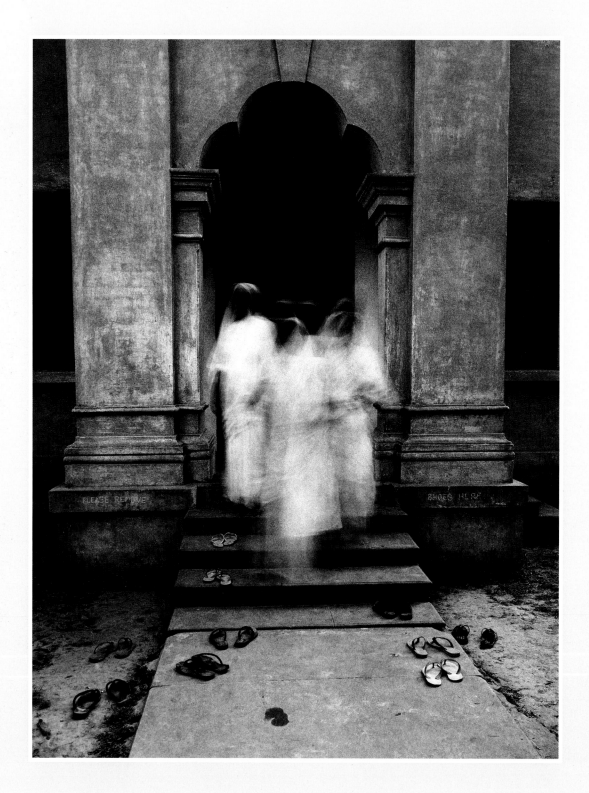

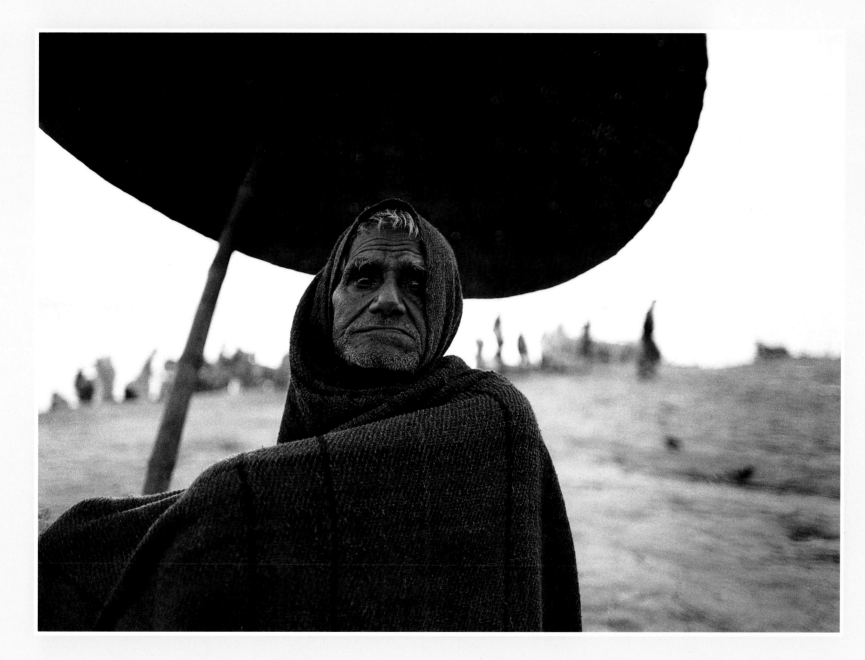

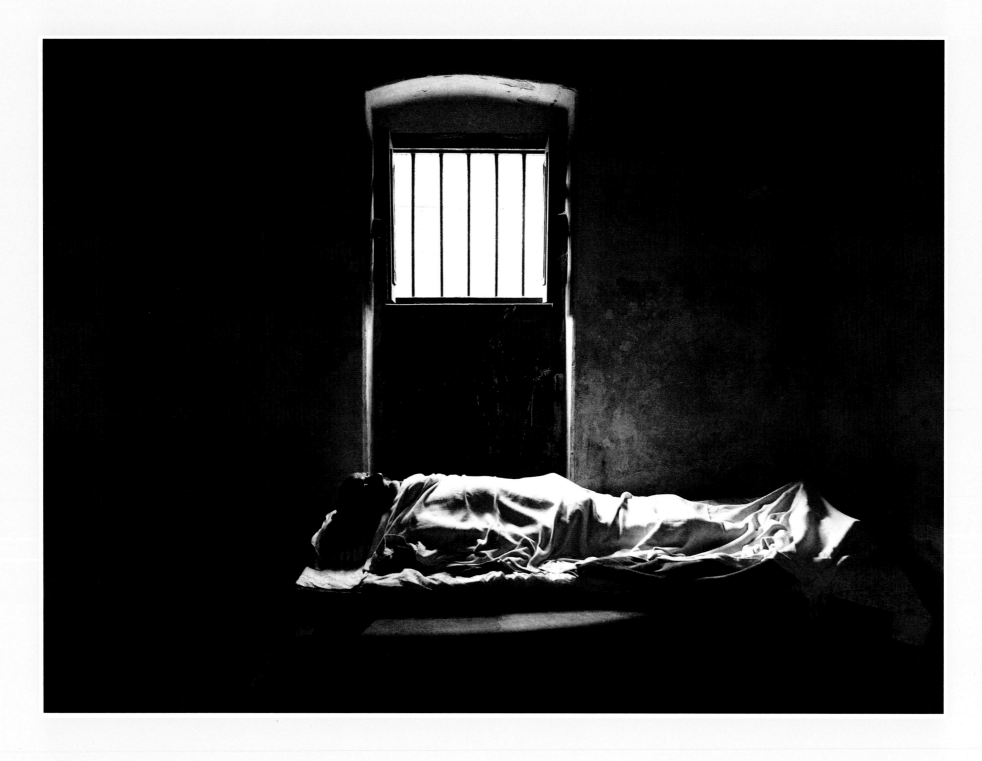

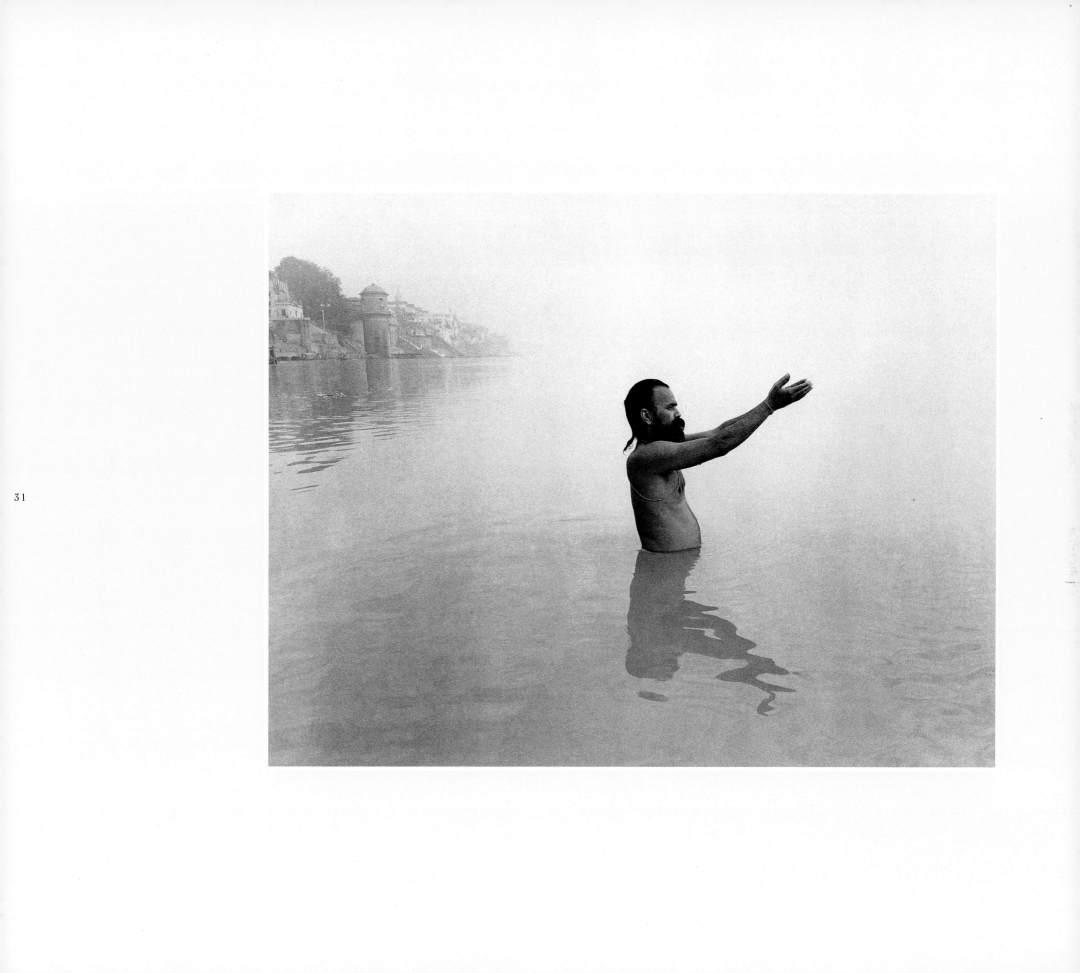

The Center of the Earth

New Guinea

THE SPIRIT COMES TO TELL ME

An interview with a tribal carver and elder of the Sepik River, New Guinea

When I was small my father made me a mask and a spear. We used to throw the spears at the masks and imagine they were men. This was so if our village was attacked, we would know how to fight back. I did not have to fight, but my father did. White man has come; many things have changed.

If my father caught a man and made him prisoner, he would cut him up and burn the body—but he would keep the head. He would show everyone the skull and tell everyone the story. Sometimes he would give a name to the head—the name of the man who was inside the head. Sometimes he would name one of his sons after the dead man. I may have gotten my name this way. Then he would put the skull in the spirit house. When I was small, the spirit house was full of skulls. They are still there.

I can see spirits when I am in my village—I see them all the time. In my house there is a healing spirit. It lives in the house posts, and it lives in the carvings. When you come to my house, you can see the spirits, too. I will take you into the spirit house. It is like a church.

In my room are masks. I keep masks to protect me. Also, the masks are the stories of my ancestors. I like to live among them. I see the ancestor mask when I am lying in bed. I see the spirit in the mask, and I can talk to it. Suppose someone is sick in the village. That is when I talk to the mask. I have cured a lot of people in this way, by talking to ancestors. I know what to say. I stroke the mask. I offer it food. The sick man brings offerings, too. It is my spirit and the spirit of the ancestor that does the healing. My father taught me, and his father taught him. The Sepik people have always been good healers and carvers.

The spirits are good . . . If the spirits are always good, how do people get sick? They get sick from breaking the rules—like the boy who was fainting. The boy's father had broken a rule; he had disobeyed one of the rules of the village. The rules are for everything, and they tell us how to live. If you break the rules of life, you can get sick, get dizzy, get fainting, get paralyzed. Then you come to me in my village. Our ancestors will help you.

You don't need to write. When someone is coming to see me, I know. The spirit comes to tell me. I will know straight away when you are coming.

Like you, I have had the experience of getting lost, finding myself without familiar landmarks, beyond known points of reference. In my case, however, I am in the business of getting lost. To get where I must go, I must sometimes move about as far from civilization as any of us can travel—as far not simply in geographic distance, but in time and human experience. In the highlands of New Guinea, for example, I once discovered in a new and different circumstance the sense that what I left behind was something I wanted to lose.

It was several years ago that I came upon the headman of a native tribe in the highlands of the Beliem Valley. We stood there for a moment gazing at each other, and then he asked me, "Which valley are you from?" It was a simple question, one anyone might ask. Beyond placing me, he was doing exactly what I was doing: trying to understand the unknown in terms of the known. I said, "I come from many valleys away." He paused, a tangle of mountain green framing him against the ridge, then asked again which valley I came from. My imagination failed me, so I could only reply, "From far, far away." The words left him momentarily lost, but then his expression lightened and he seemed to understand. "I know," he said, "you come from where the green meets the blue."

Now it was my turn to pause. It took me a moment, and then I nodded. Yes, I suppose I did come from where the green meets the blue, green earth meeting the blue of sea and sky. We both came from there—the biosphere itself. Here on a mountain ridge deep in the interior of New Guinea, I could not help but feel disconnected from everything: my past, the forest stretching into the distance below, any sense of the world as I had known it. Then the irony began to dawn on me. While the old man in front of me could stretch his imagination to explain me in terms of a place, I would have a much tougher time understanding him, for here was someone from another time.

On an evolutionary scale, we both had started at the same place long ago, and somewhere along the line our ancestors had made some choices that led to the differences I now observed. By returning through time, I had found the opportunity to see my own more original self, a self that appeared in a most unexpected way.

At the headman's invitation, that night I entered a spirit house. Crouching low to fit through the small door in the bamboo, I emerged into a darkened, smoky room where the fifteen or so elders and boys were sitting cross-legged while one of them slowly told a tale. As my eyes adjusted, I realized that in the corner, in a place of reverence, hung the remains of a mummified ancestor.

I sat in the circle and fell to gazing at the flames dancing from a fire in the middle of the hut. The heat held the chill of the mountain air at bay outside. The murmuring voices of the men told of the day's hunt and the demon spirits waiting in the black of the forest. As the fire flickered on native faces, the men's stories seemed to empty me of thoughts, of self. My role as an observer was suddenly gone, and the distance now closed between us. Quite clearly I had been here before, but just how or why I could not say. I could feel as a quickening force within me the primary connection between man and Earth.

Here in the smoke and gloom of the hut, I was listening to the story of man before the written word, before Abraham and the Old Testament, before the Rig-Veda, before Homer and the Iliad. It was the oldest of stories: the hunt, the influence of the spirits, the traces back to the beginning. Smoke mingling with the thatch above, the smear of pig fat on the bodies next to me, bird of paradise feathers in their hair, bones around their necks, the mummified ancestor silent in the darkness of the corner, my torn cotton shirt and khaki pants, the blue scarf around my neck—we were no different. For a moment, we were one. We have all been here before, and in the eyes of nature we are all still the same.

I have no illusions about returning to the Garden of Eden, for I have been among the natives of New Guinea enough to see that they also share with us the dark side of human nature. And I am well aware that even as a solitary visitor with a camera, I represent the risk that difference brings to isolated peoples. But I found, at least for a moment, some wisdom there among the Yali, whose voices said that man and the Earth are one, and that what man does to the Earth, he does to himself.

Maybe that is what we have lost, speeding along in our air-conditioned cars or crouching before our glowing screens with pictures of life parading before us: We have lost the direct experience with nature itself. It is an ignorance we cannot afford, for nature can exist without mankind, but can mankind exist without nature?

New Guinea, an island north of Australia, contains two separate countries: Papua New Guinea and Irian Jaya. Irian Jaya is in fact a province of Indonesia. Many of the Irians do not believe they are Indonesians, but rather that they belong more to the peoples of the island of New Guinea. These photographs were taken over an eight-year period of travels to different isolated locations on the island. Travel, often by dugout canoe and precarious airplane, is difficult. Many of the tribes photographed have had some contact with Westerners. A few have not, and others have had considerable contact.

Page 38: Boy with bow and arrow performing a practice that is a part of the manhood initiation rites, Highlands, Irian Jaya

Page 39: Running men gathering wood for pig festival, Highlands, Irian Jaya

Page 40: Mudmen in ritualized re-creation of dance, Mt. Hagen area, Papua New Guinea

Page 41: Wigman of the Huli tribe and local bridge, Tari Highlands, New Guinea

Page 42: Chief of tribe, Mt. Hagen area, Highlands, Papua New Guinea

Page 43: Tribesman from village near Port Moresby, Papua New Guinea

Page 44: Two hunters shooting birds, Irian Jaya

Page 45: Yali tribesman, Highlands, Irian Jaya

Page 46: Woman and baskets, near Angorrak, Highlands, Irian Jaya

Page 47: Yali hunter drinking water, Highlands, Irian Jaya

Page 48: Woman with tattoos signifying that she is from a tribe on the eastern coast of Papua New Guinea

Page 49: Dancer painted, Gawa island, Papua New Guinea

Page 50: Two women in mourning, covered in mud and wearing Job's tears beads, one of which is removed every day as the mourning continues over several months

Page 51: Mendi woman in wedding costume, Mendi valley, Papua New Guinea

Page 52: Dani man paying respect to smoked elder, Dani village, Beliem Valley, Irian Jaya

Page 53: Man sleeping on ancestral skull to ward off evil spirits, Asmat area, Irian Jaya

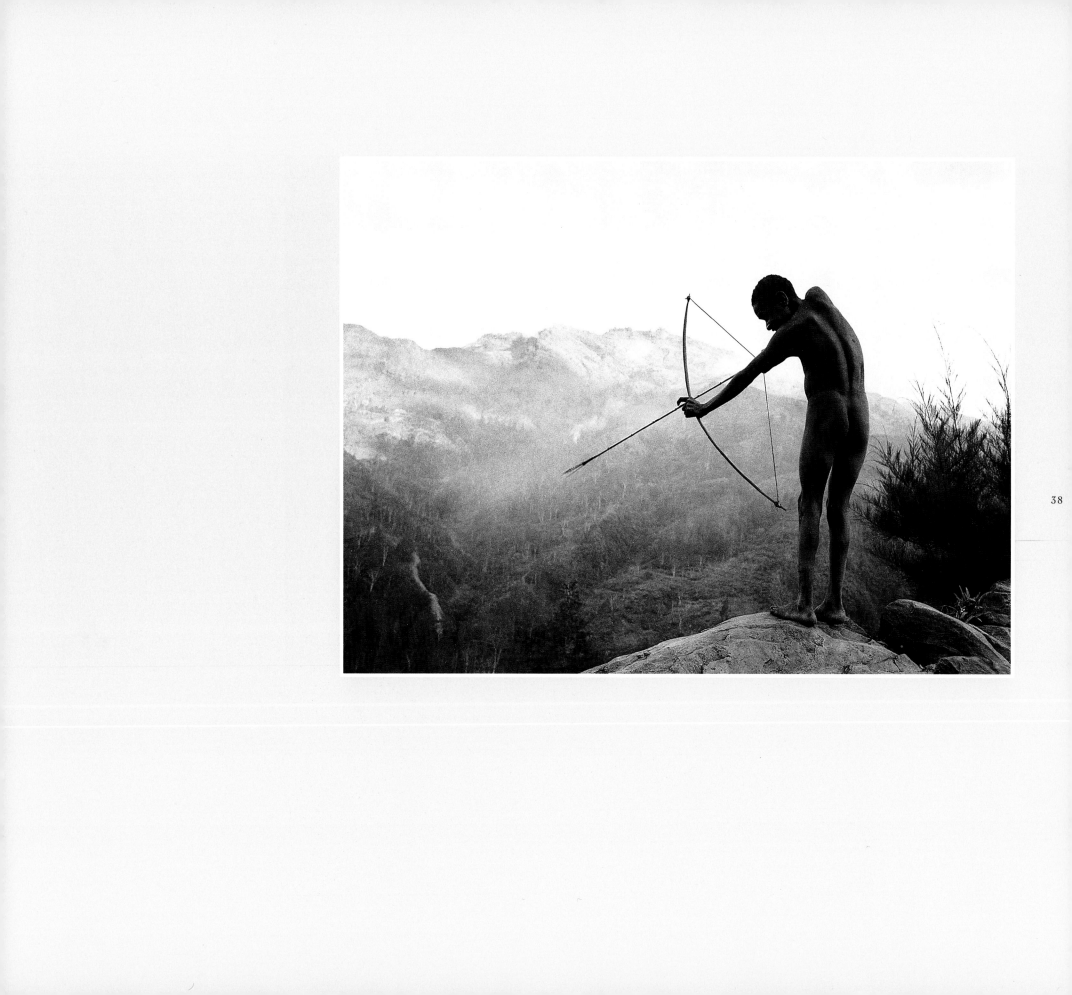

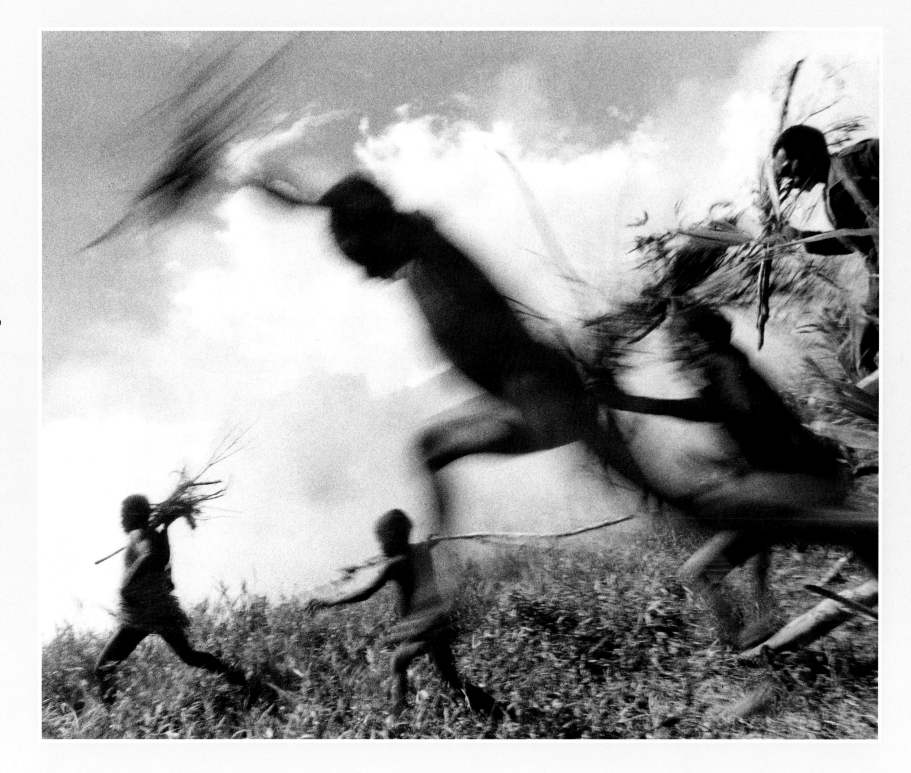

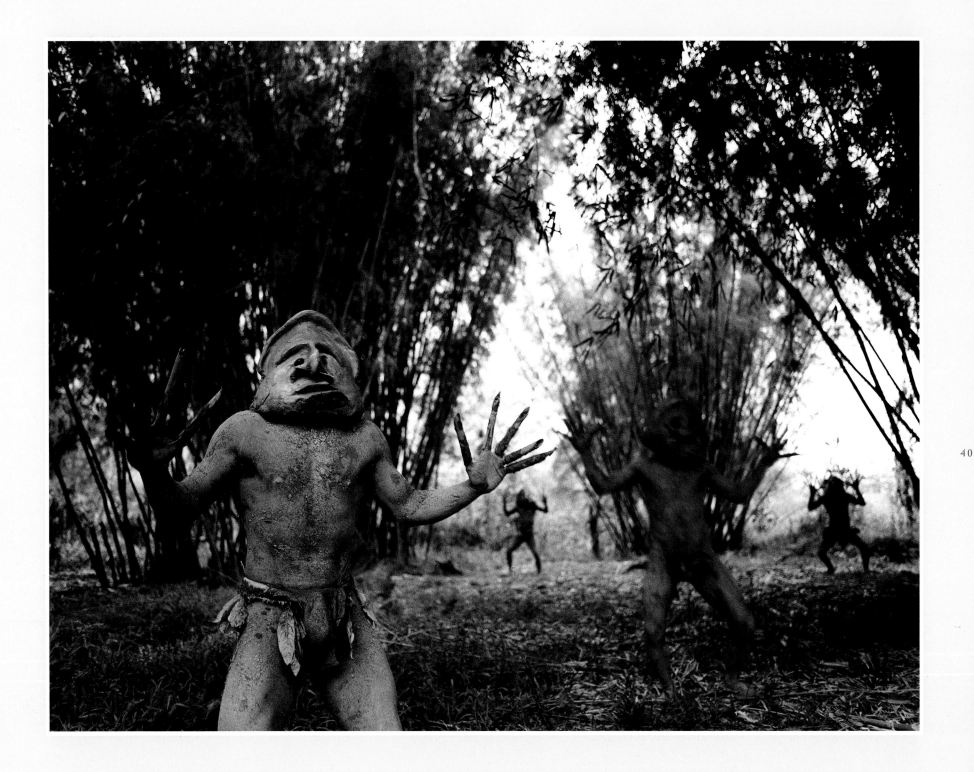

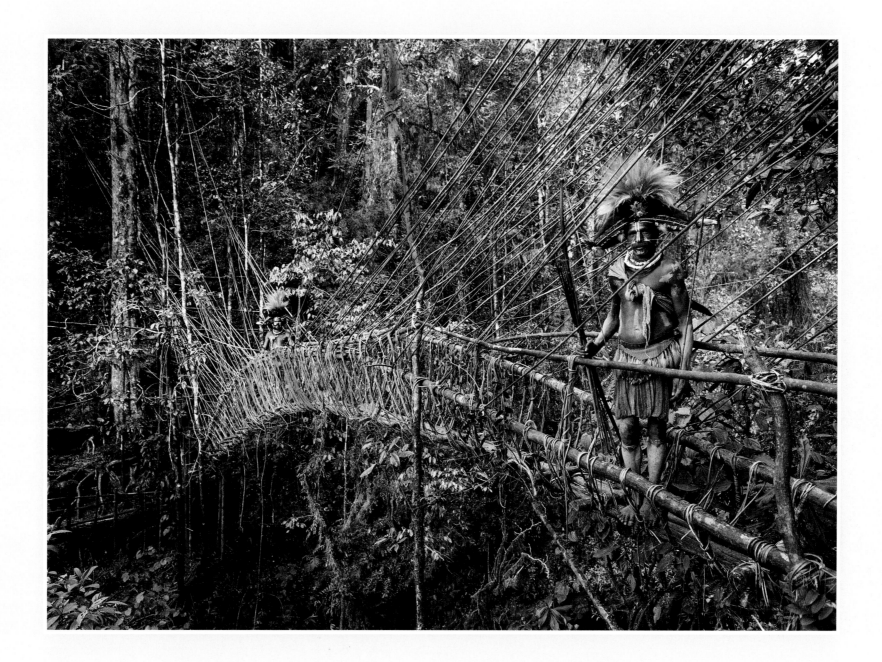

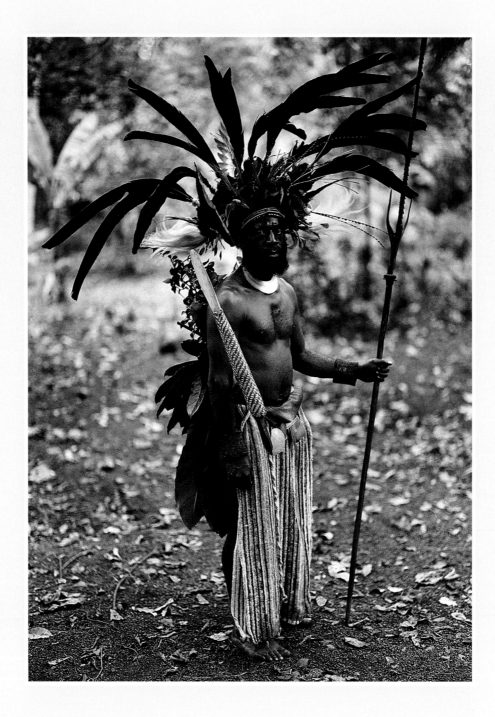

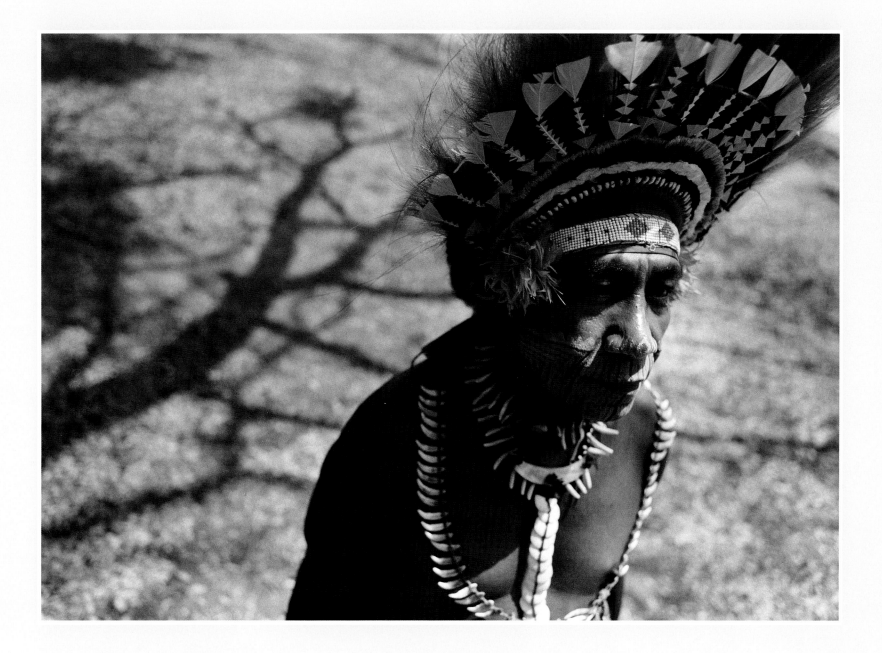

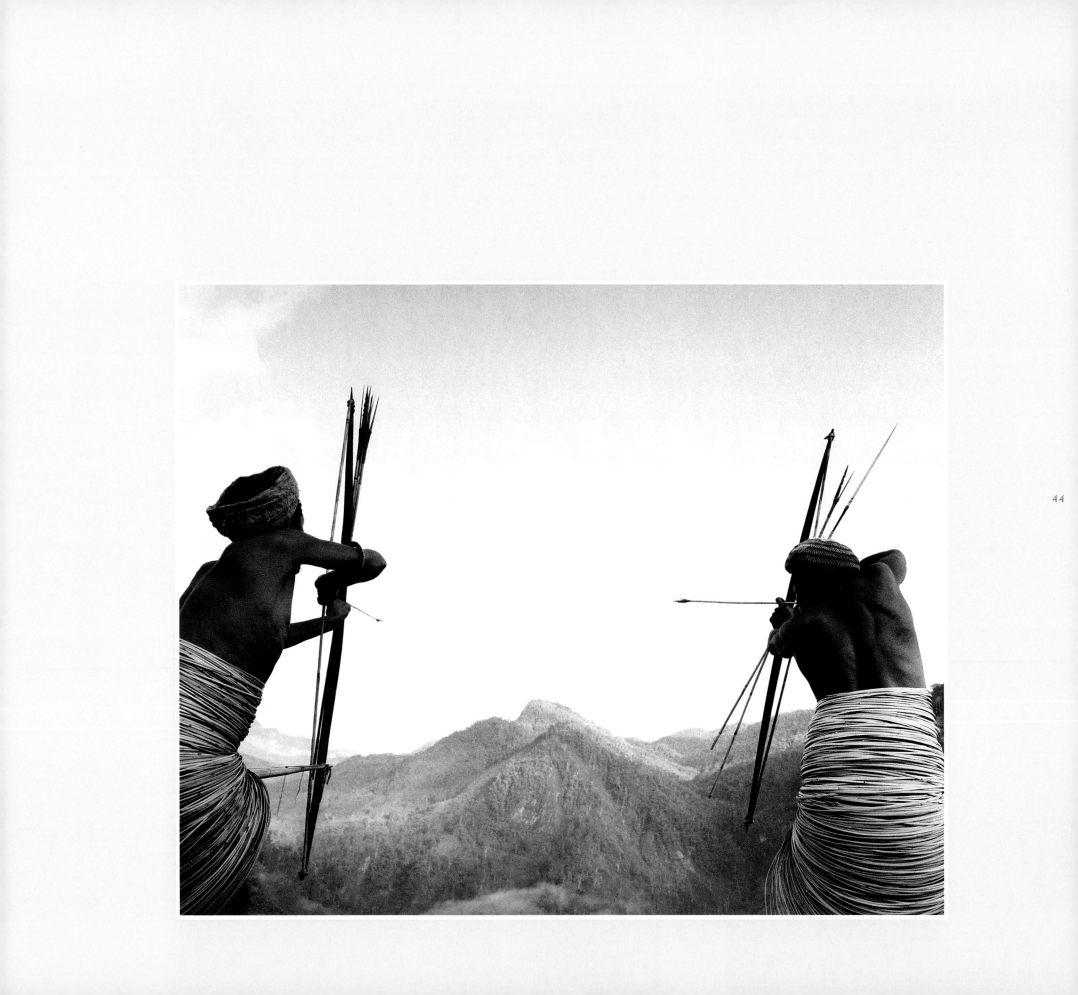

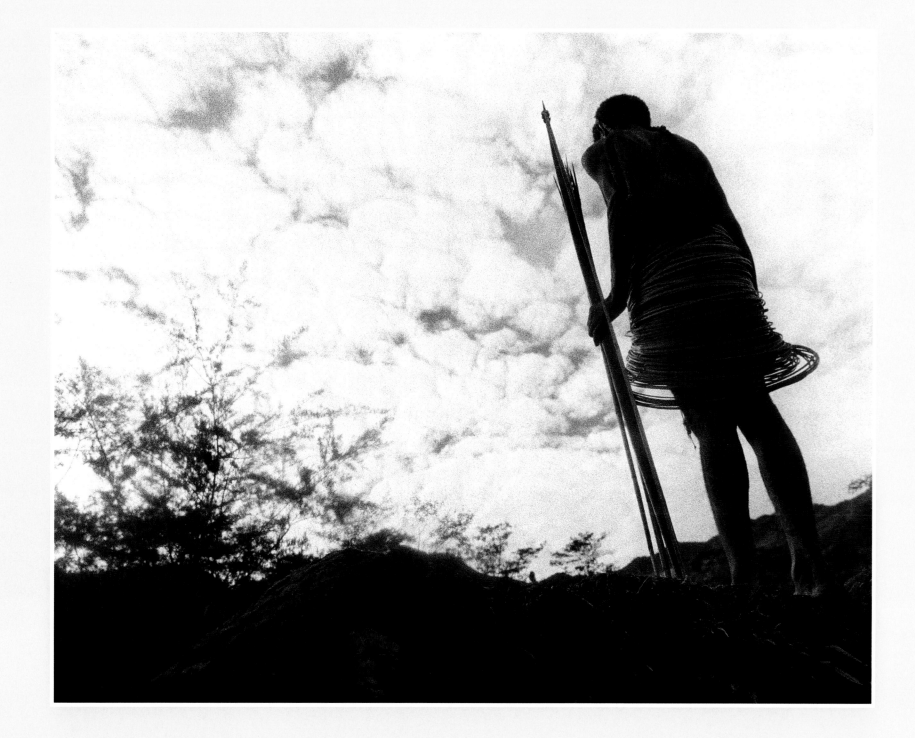

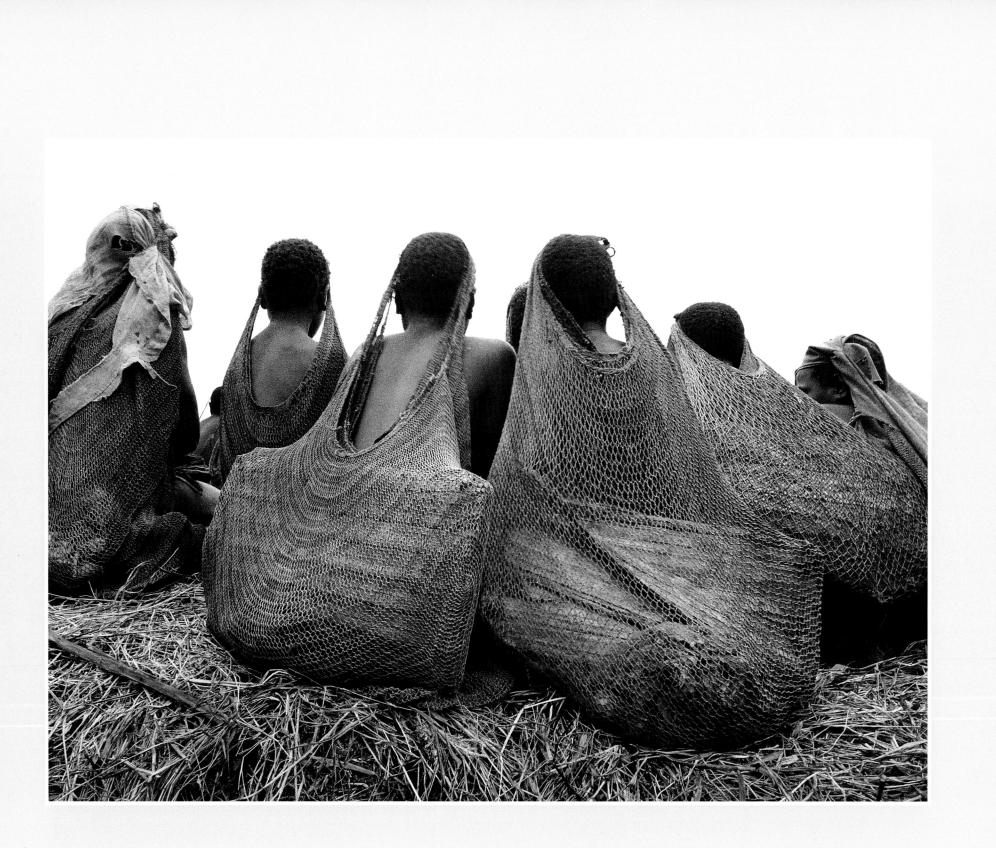

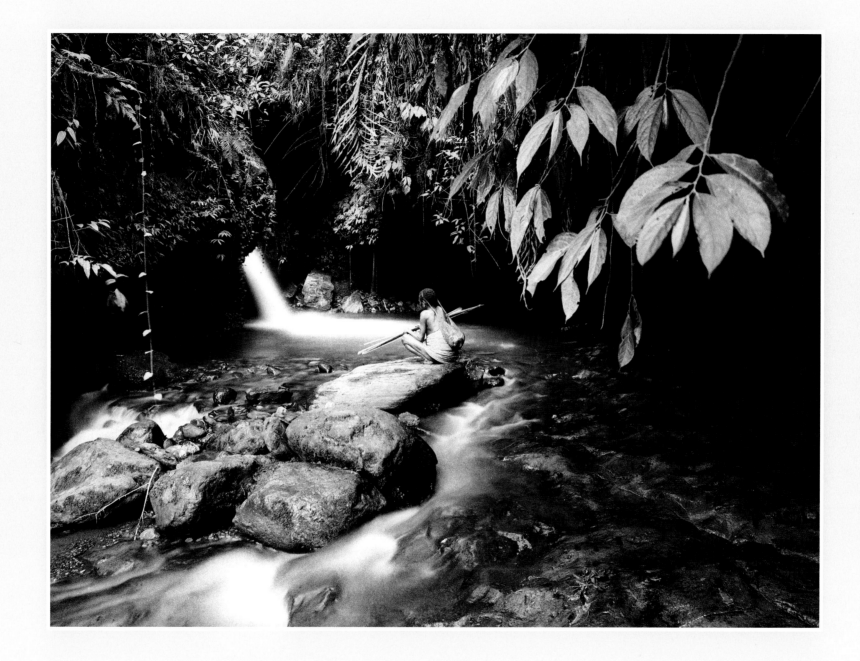

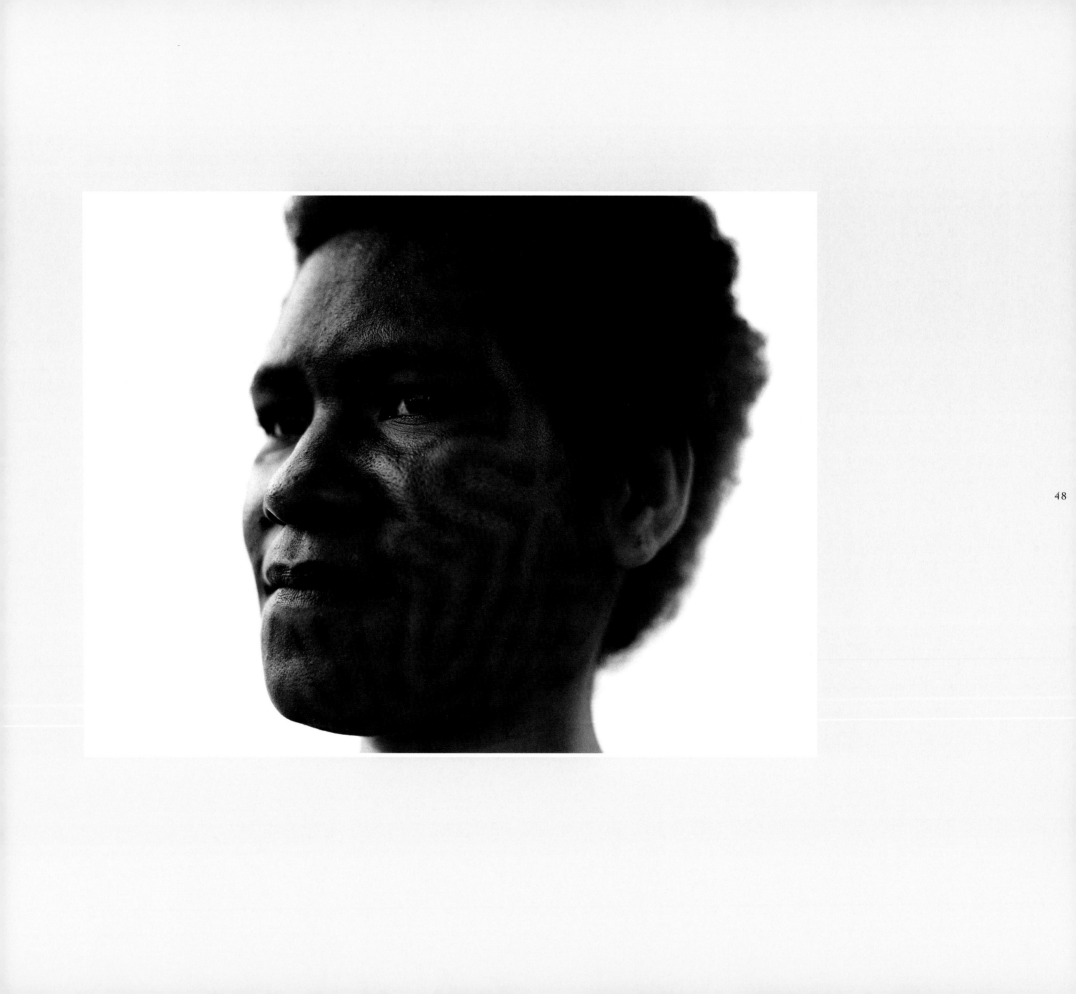

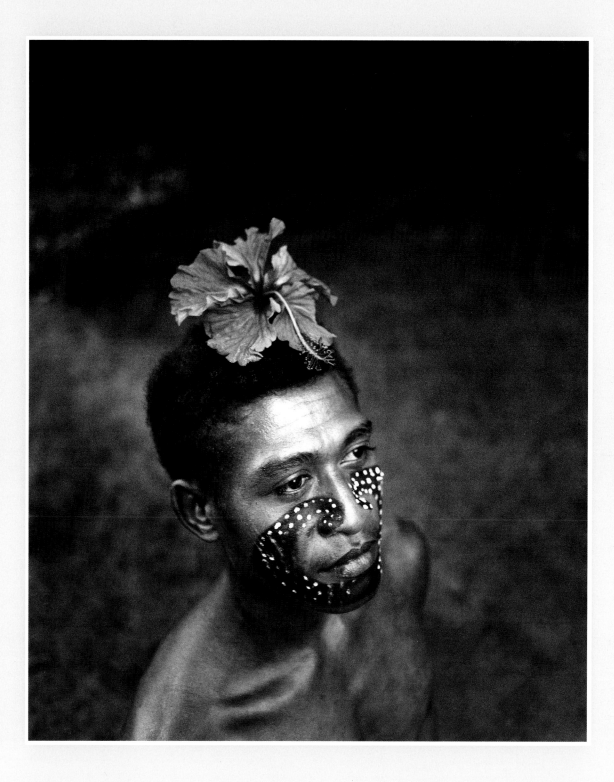

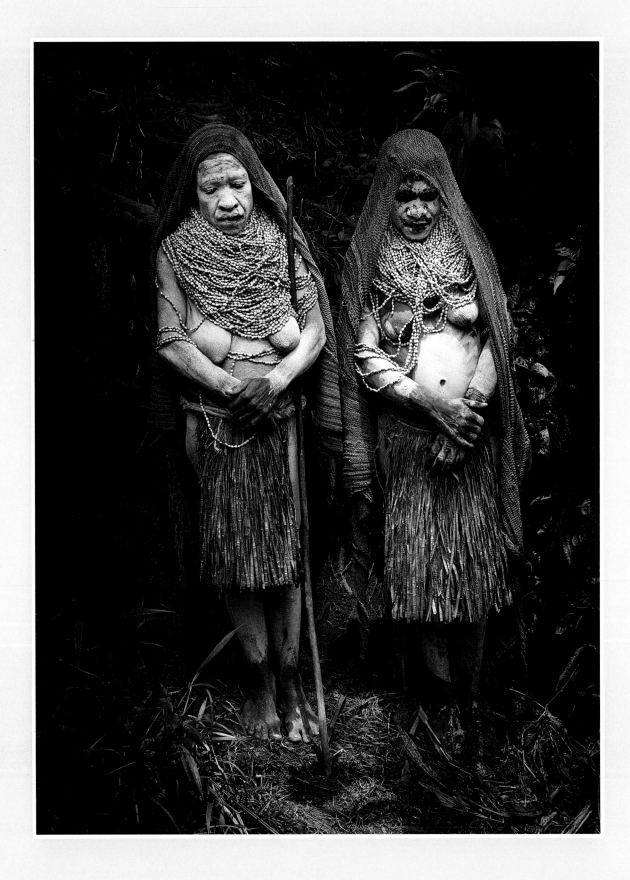

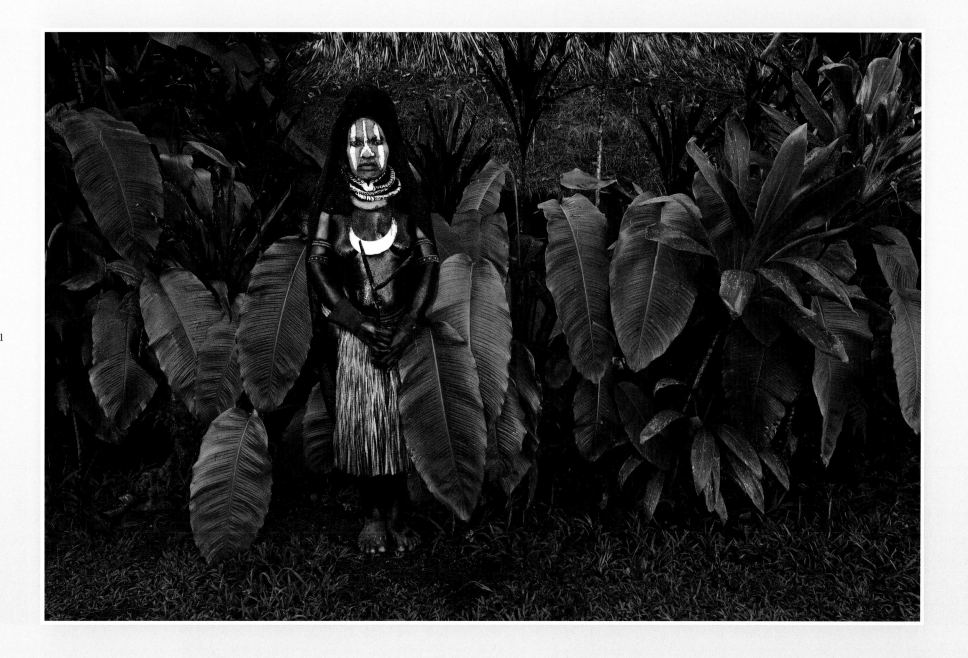

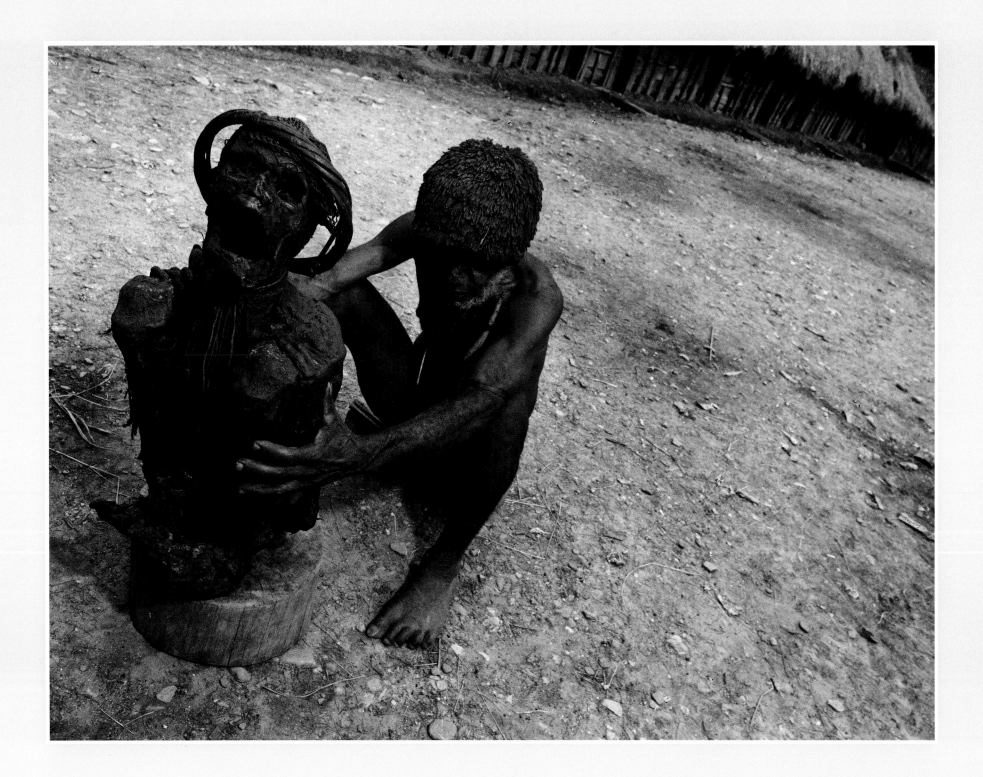

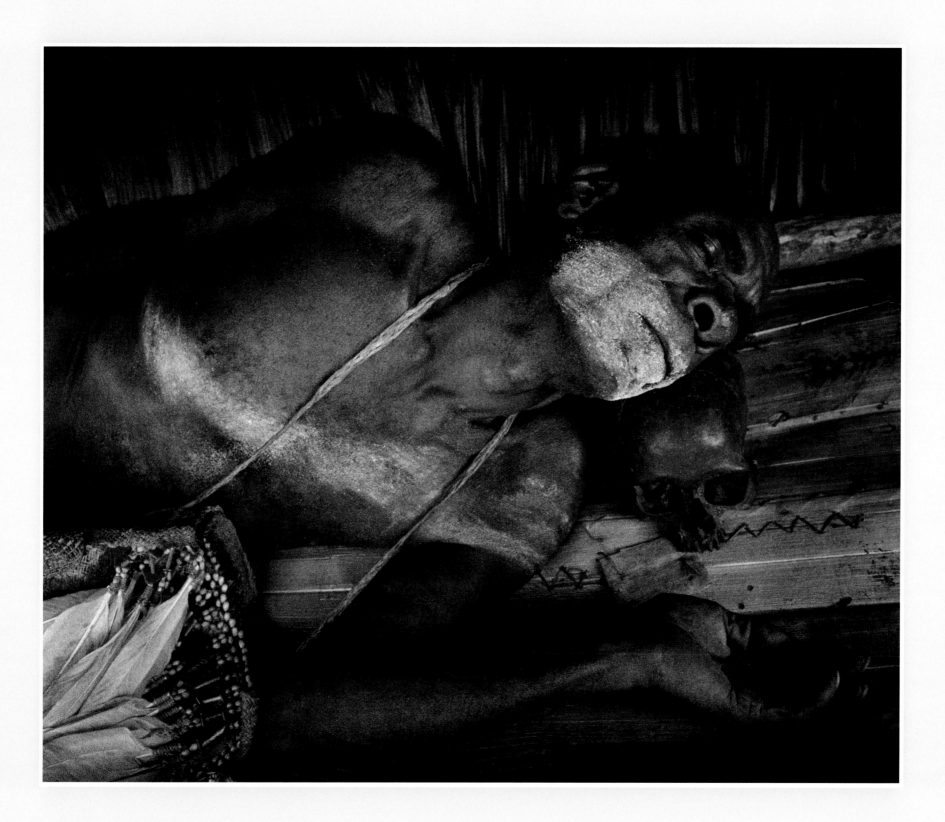

The Land of
the Snow

Tibet and Ladakh

INNER PEACE, UNIVERSAL RESPONSIBILITY

The Dalai Lama

Tibetans are always described by foreign visitors as being happy, jovial people. This is part of our national character, formed by cultural and religious values that stress the importance of mental peace through the generation of love and kindness to all other living sentient beings, both animal and human. Inner peace is the key: if you have inner peace, the external problems do not affect your deep sense of peace and tranquillity. In that state of mind you can deal with situations with calm and reason, while keeping your inner happiness. That is very important. Without this inner peace, no matter how comfortable your life is materially, you may still be worried, disturbed, or unhappy because of circumstances.

The realization that we are all basically the same human beings, who seek happiness and try to avoid suffering, is very helpful in developing a sense of brotherhood and sisterhood—a warm feeling of love and compassion for others. This, in turn, is essential if we are to survive in this ever-shrinking world we live in. For if we each selfishly pursue only what we believe to be in our own interest, without caring for the needs of others, we not only end up harming others but also ourselves. This fact has become very clear during the course of this century. We know that to wage a nuclear war today, for example, would be a form of suicide; or that to pollute the air or the oceans, in order to achieve some short-term benefit, would be to destroy the very basis of our survival.

Ultimately, the decision to save the environment must come from the human heart. The key point is a call for a genuine sense of universal responsibility that is based on love, compassion, and clear awareness.

In the high country of Tibet, beyond the great peaks of the Himalayas, the driving winds and absence of water leave life clinging sparely to the landscape. As they herd their yaks and farm in rock-strewn valleys, the people here reflect the tenuous grip life has on unforgiving surroundings. Here you step to the edge, and life has no room for extravagance. Death has a real face and a real presence in the moment, and your identity trembles.

In Tibet they still perform the ancient ritual of the sky burial. In the harsh chill of first light one morning, I came upon just such an event. Four monks in burgundy wool robes were gathered at a sacred rock set half a mile above the village. It was a safe distance, enough to separate death from the flow of early-morning life below. As shafts of sunlight broke across a huge rock some fifty by twenty feet, I rounded an outcropping to find four monks carving and hacking apart the body of a brother monk who had died two days before.

These monks are forbidden to kill any living thing, from the smallest of creatures to the largest of plants. Yet here were four men, devoted to life, now in a sweat carving, hacking, and breaking bones, dismembering someone whom they had recently honored as a friend. In life, harming him would have been unimaginable.

They seemed incredibly nonchalant, chatting as if they were breaking up firewood, as if they were so accustomed to reducing the remnants of human life that it was no different from any other task. There was no affront to human dignity here. In fact, they appeared to find their ritual a serious business, yet also a kind of whimsical celebration of their friend passing through death into the next life that each of them longed for.

The human response to death is both instinctive and learned. At first, I was somehow repulsed yet unable to stop watching. Like butchers in some open-air market, they had each taken a section of the unlucky deceased and moved off around the rock to reduce it to smaller parts. Like butchers, each knew what he was about with bone and joint and muscle. Over the course of half an hour, the deceased monk—legs, arms, trunk, head—was reduced to remnants each no bigger than roughly what would fit into your hand.

Although I had attended my share of Western funerals, up to that point I had not seen death. I was not prepared for this frightening display, but because they had done this mortal work many times before, there was no sadness, no loss, no sense of disrespect, not even a sense of the mortal coil shuffled off. Here was belief so strong that it said: He is merely changing form, and we are here to help. It was apparently essential that the remains of this man find new form in the life of another creature. Still, here were friends dismembering someone close to them, human beings practiced in the art of reducing a man to his constituent parts.

And now I looked up to find from the sky vultures practiced in this ritual as well. The first monk tossed a piece of his late comrade high into the air, a clear offering to the birds. A vulture swooped in as if trained and caught the piece halfway on its descent. Weighted by its unusual capture, the bird found itself pulled down briefly, until, with a great flapping of its sweeping black wings, it rose and overcame its temporary wrestle with gravity. From

nowhere others followed, gliding in to take the high-tossed remnants of the monk.

I stood silently immobilized, attracted by this eerie procedure yet deeply terrified by the finality of the act. The great stone was worn like a footstep, apparently from centuries of monks moving their deceased brothers through this ritual transformation. Those who had watched, like me, had eventually found their place on the rock and with the birds.

As each bird began pecking at its welcome portion, I saw that in having man turned into food for another creature lay the true testimony of belief. From death comes both release and new life. The ritual said: Do not try to hide from it. Do not delude yourself that it can be any other way. Life and death are one, equals, partners. Each is a sequential part of a process stretching beyond the brevity of a single life to form the turning wheel of all life.

In coming here to Tibet to photograph the process of life, I was also inevitably capturing death. Photographers and the photos they take are inescapably part of the great cycle of all things acting out, in changes small or large, the mystery that turns matter into energy, then again into matter. Whatever your pride, your sense of self-dignity, your delight in capturing the quintessential image of this puzzle, whatever your denial of the inevitable, your carefully cultivated sense of your self as altogether different from any living thing that has ever appeared, you are in a moment food for a vulture, and then humble bird droppings. The message of Tibet is unmistakable and unforgiving: Each of us simply waits to take another form, to become irretrievably another part of the wonder of all things living and not living in the cosmic flux.

Here beyond the Himalayas it is possible to conclude that what you don't accomplish holds equal importance with what you do. Here the absence of life, the void created by nature, forces you to examine a spiritual dimension we in the West somehow lose in our trips to the gas station, the grocery, and the bathroom mirror. Here dreams of possession as happiness and of accomplishment as immortality are tinged with a dark whimsy. Celebrating the self becomes an absolutely useless exercise. You realize that you don't own your body, for it is only available to you for a short term. Whatever your willpower and strength, how far can you throw yourself forward into eternity?

Tibet has the power to leave me feeling absolutely dwarfed by nature, but the death imminent on the harsh Tibetan plateau forces me to feel most alive. In the stillness of the stark landscape, I can feel my breathing, feel the bite of the air passing from outside into me. I become the surroundings, the air, the snow, the rock of mountains, and the high sky of heaven.

The Himalayas are a vast range of mountains on the Asian continent. Ladakh and Tibet are adjacent regions on the Tibetan plateau to the north of the Himalayas. Ladakh is under Indian control, and Tibet is under the Chinese. The people who live here consider themselves Buddhists and people of the Tibetan plateau first and foremost. Scattered throughout the valleys and high plateaus are monasteries and villages where these images were taken between 1984 and 1989, including a period of several months when I lived in a Ladakh monastery photographing the daily lives of the monks.

Page 60: Monk sitting beside window in prayer room, Rizong monastery, Ladakh

Page 61: Lamayuru monastery, Ladakh

Page 62: Hilltop shrine of prayer rocks and prayer flags at the top of the pass between Lhasa and Shigatse, Tibet

Page 63: Mani wall with white Chorten, a place of offerings to deceased Lamas, Leh Valley, Ladakh

Page 64: Roof of Gompa overlooking valley, Tiske monastery, Ladakh

Page 65: Young monk squatting before main Gompa, Tiske monastery, Ladakh

Page 66: Old Ladakh woman by wall, Tiske monastery, Ladakh

Page 67: Two monks holding photograph of The Dalai Lama and circling in prayer, Leh monastery, Ladakh

Page 68: Handprints and prayer wheels, Leh monastery, Ladakh

Page 69: Woman nursing child on steps, Leh monastery, Ladakh

Page 70: Young monk, Phyang monastery, Ladakh

Page 71: Grandfather and grandson, Leh, Ladakh

Page 72: Woman in doorway wearing festive Ladakh dress and headdress studded with turquoise and orange beads, which is often worn to weddings, Leh, Ladakh

Page 73: Young woman, Tibetan shrine, Leh Valley, Ladakh

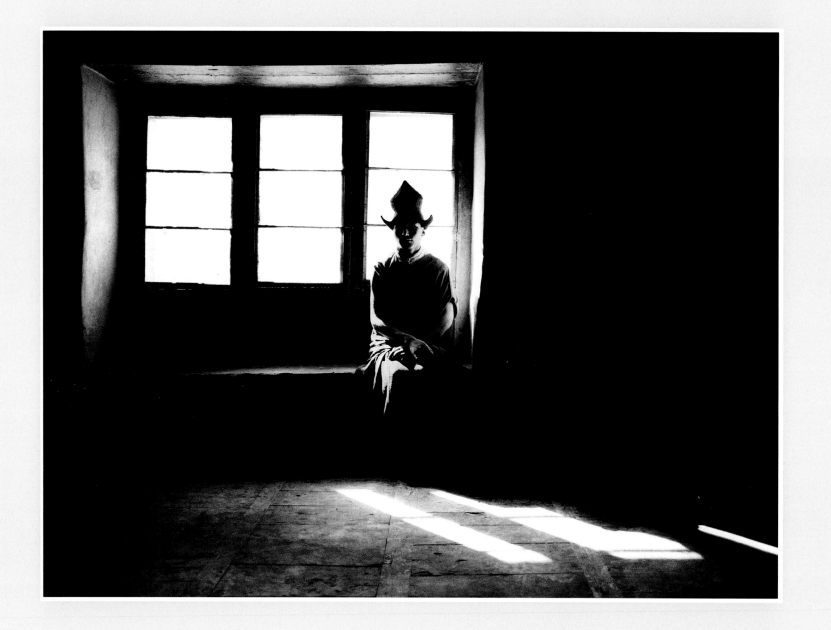

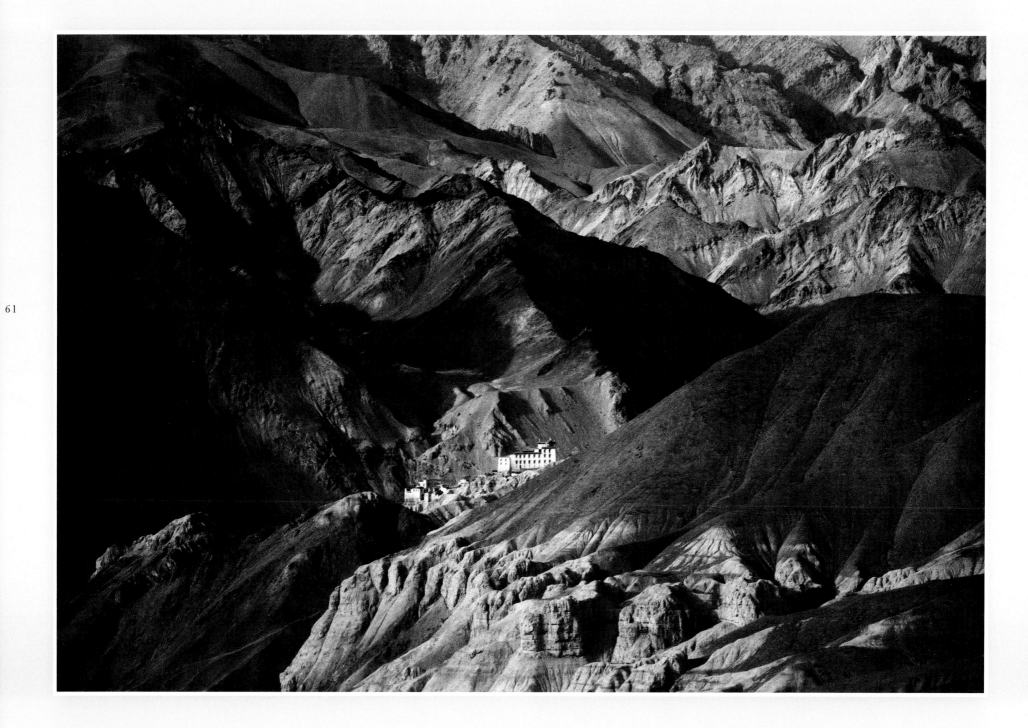

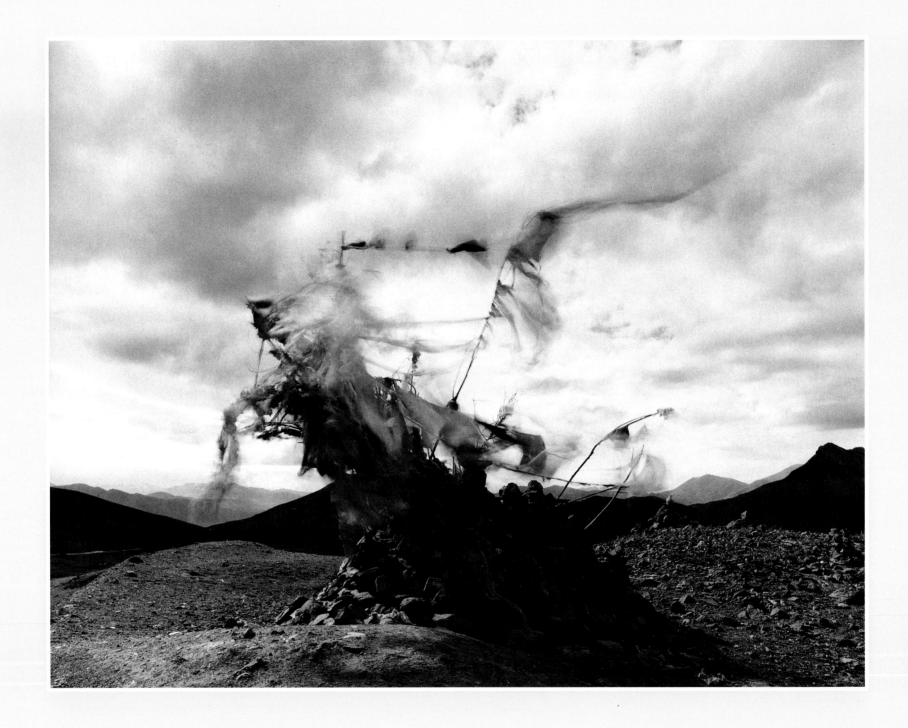

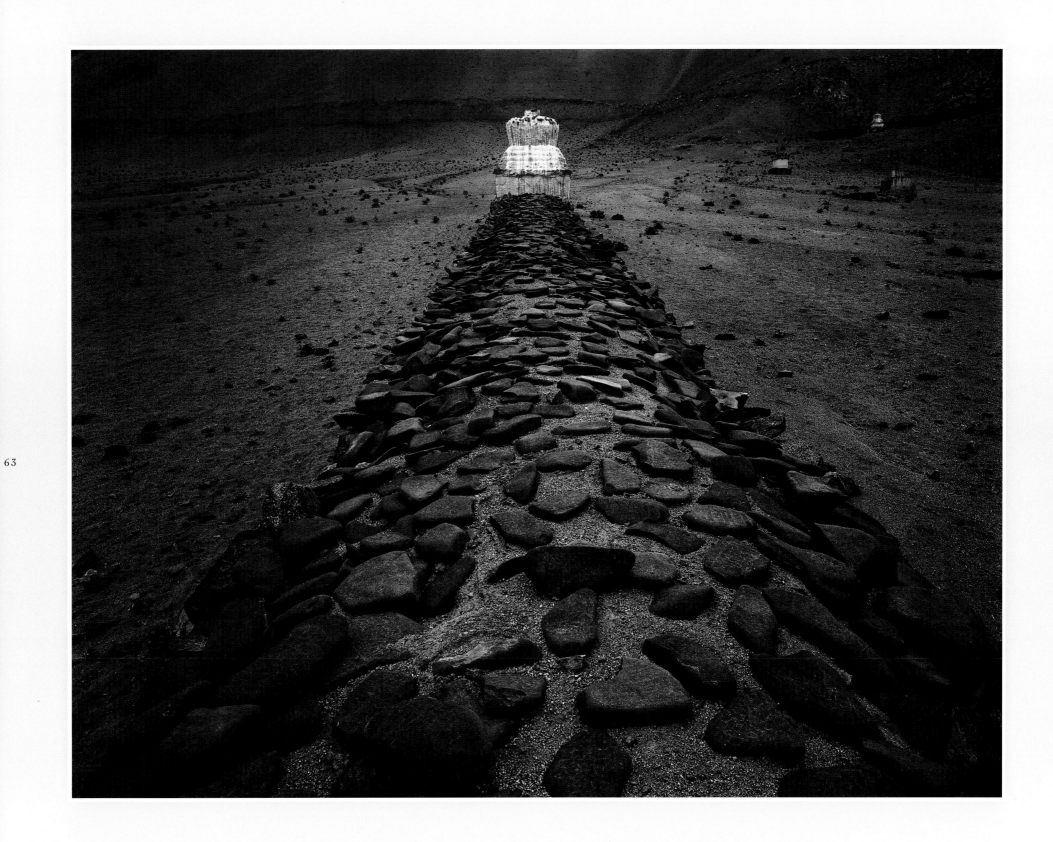

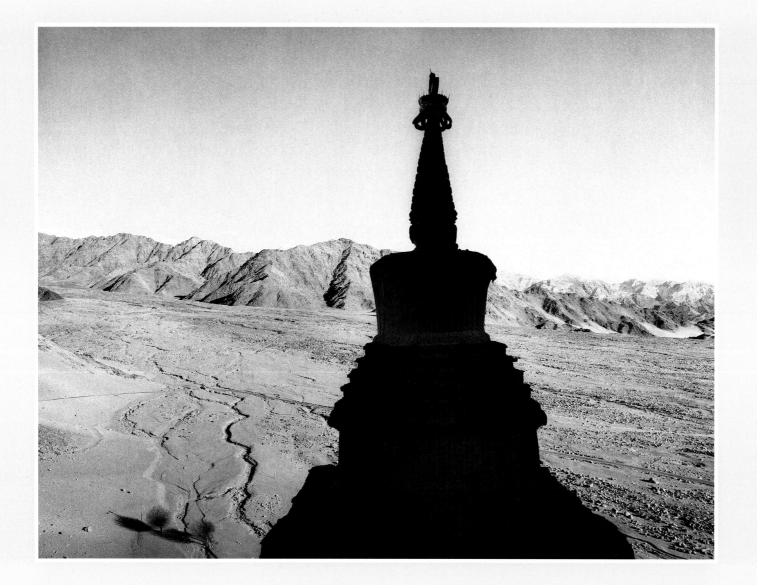

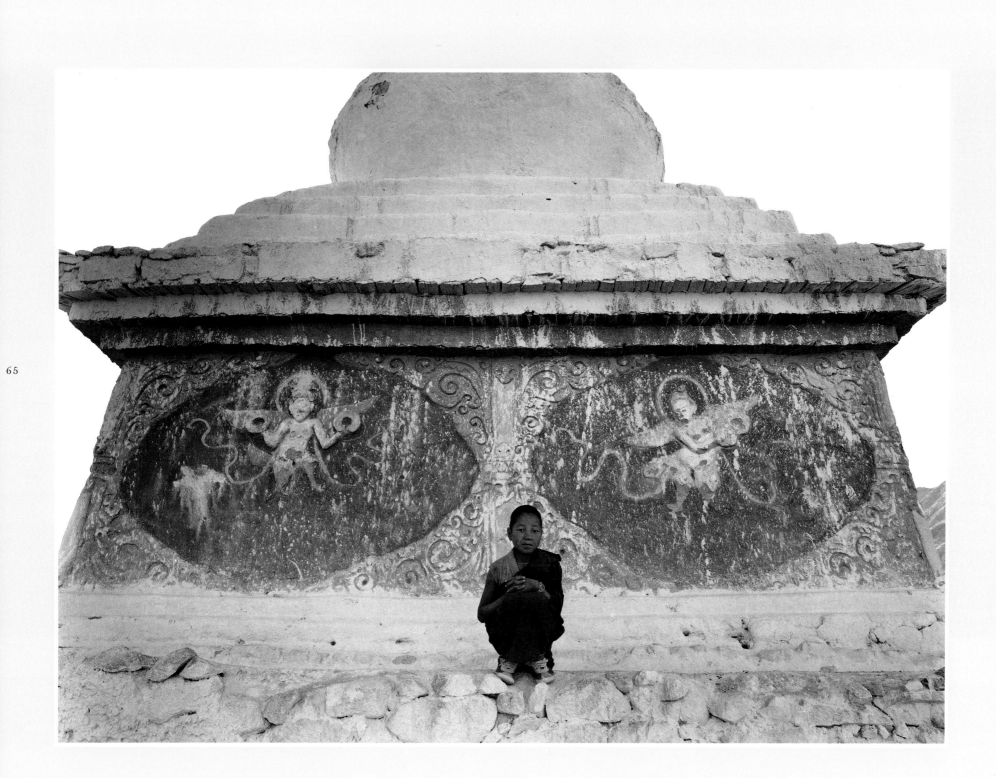

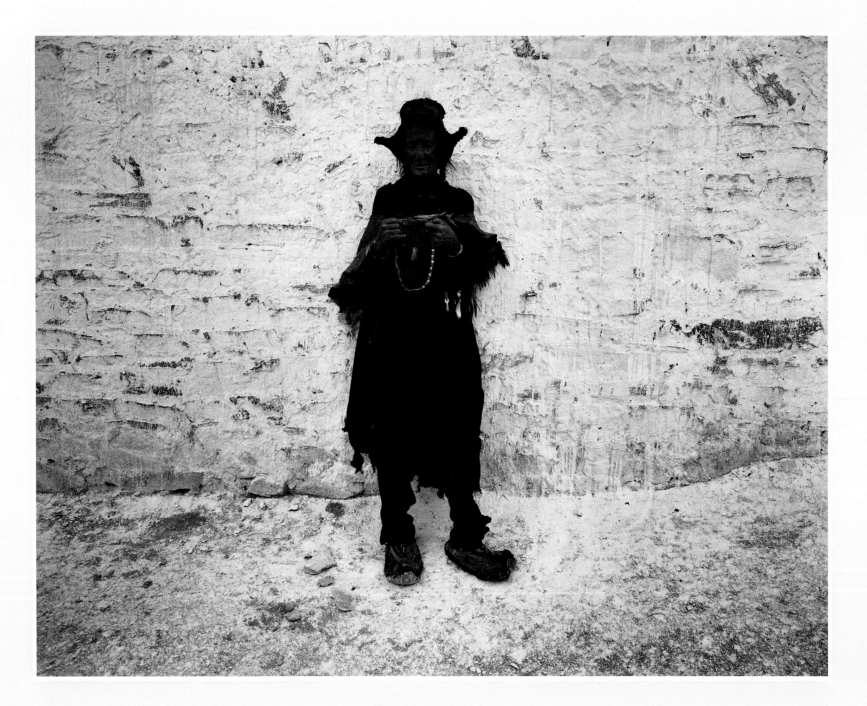

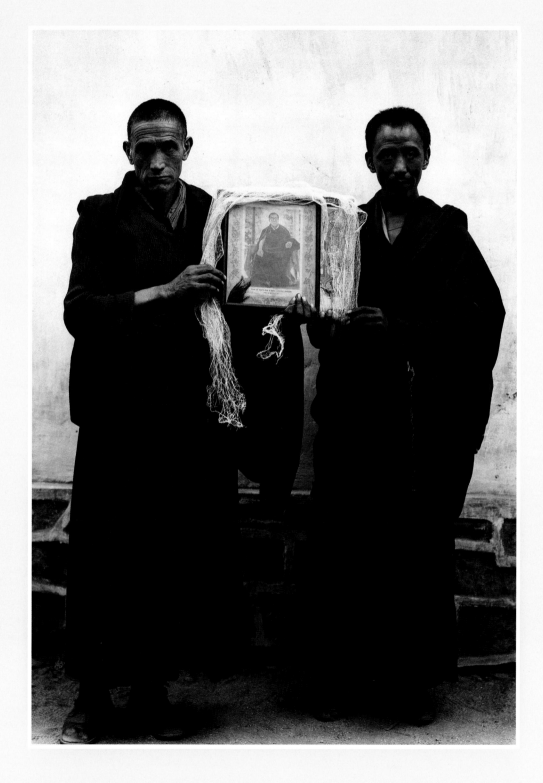

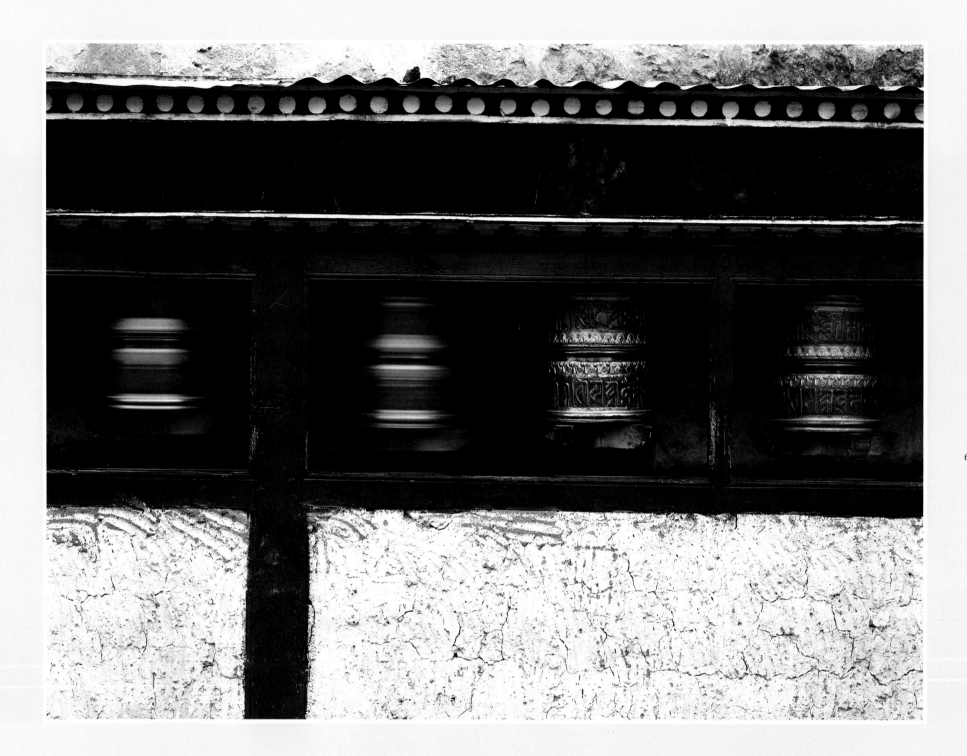

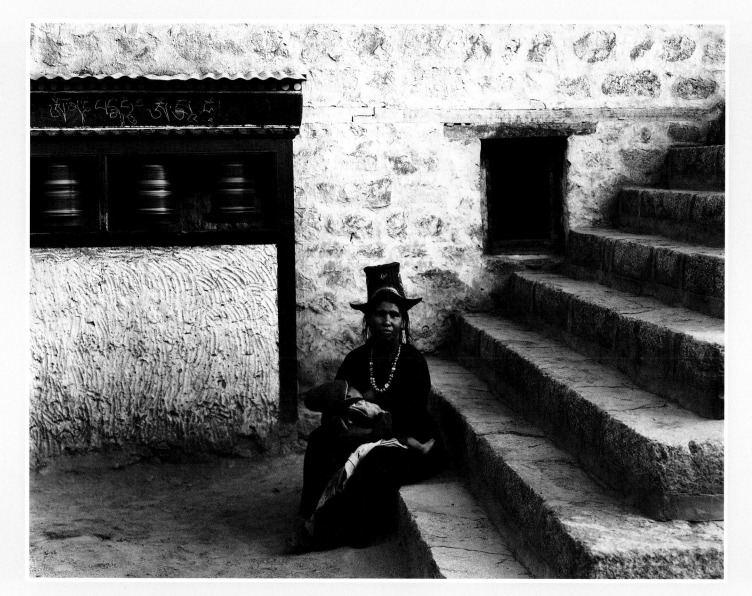

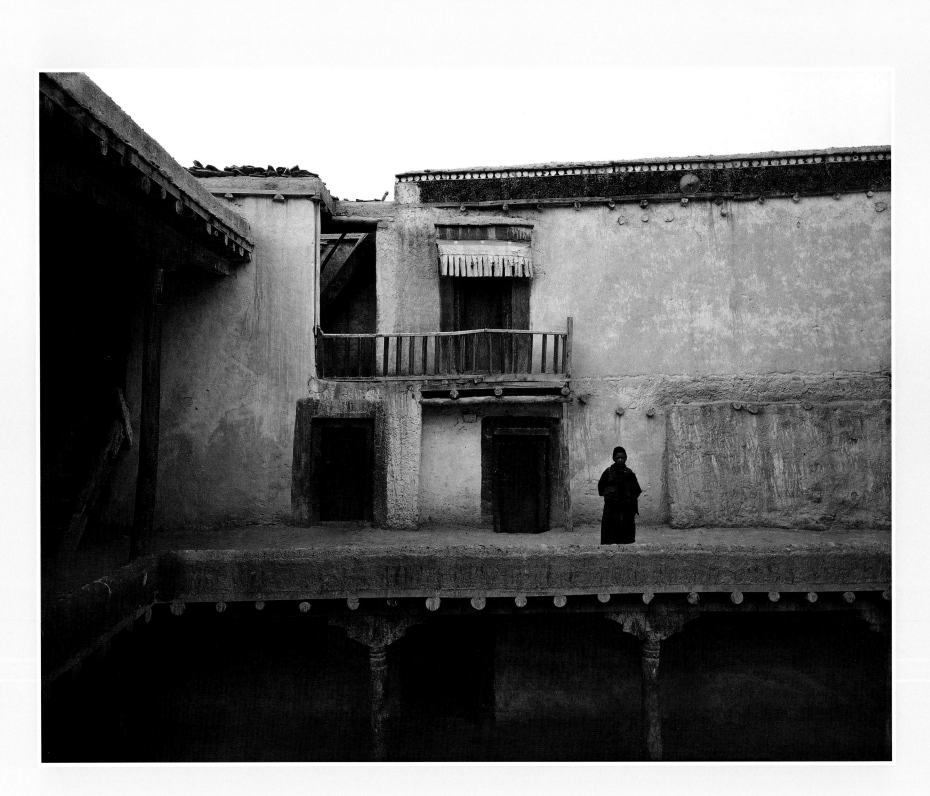

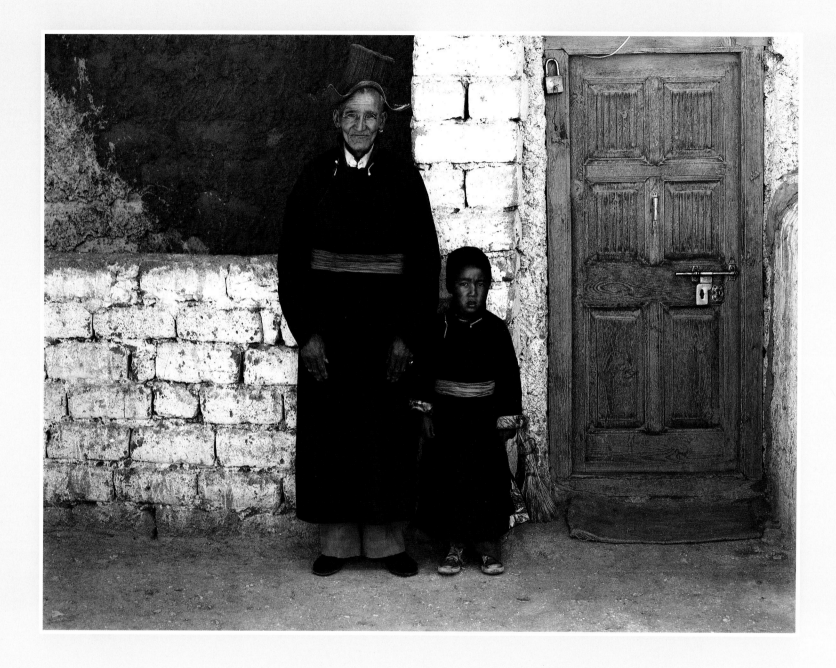

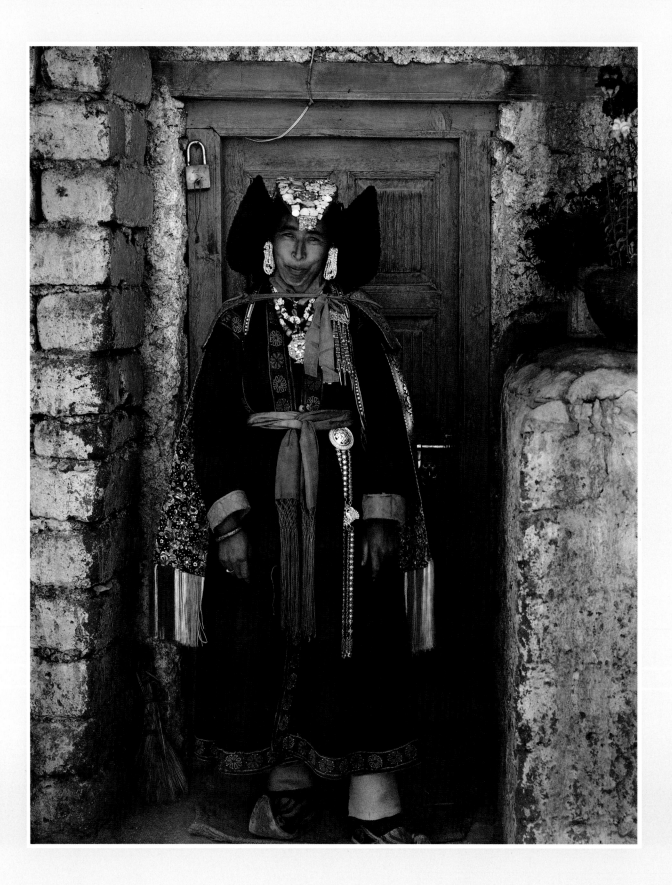

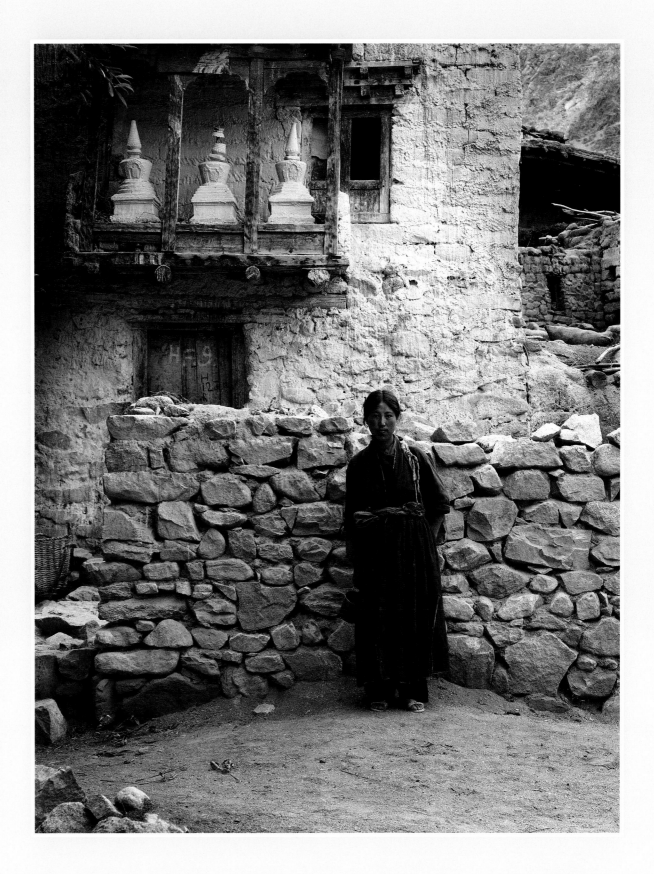

Haida Gwaii

The
Queen Charlotte
Islands

SACRED CONNECTIONS TO THE LAND

David Suzuki

In a world increasingly dominated by the growth imperative of global economics, the infatuation with technology, and the ever-expanding demands of an exploding human population, we cling to assumptions founded on the inadequate Cartesian and Newtonian worldview. Are there other perspectives from which to make our judgments and assessments, other ways of perceiving our place in the cosmos? I began to realize that other profoundly different notions of our relationship with Nature do indeed exist when I became involved in the early 1980s in the battle to save the forests in the southern part of the Queen Charlotte Islands. This was the first in a series of experiences I had with different aboriginal peoples that opened me up to new possibilities and different, richer perspectives for understanding the world.

Canada's westernmost archipelago, off the tip of the Alaska panhandle, is the home of the Haida people, who know the islands as Haida Gwaii. As a journalist, I interviewed a young Haida carver who is now called Guujaaw. I asked him what difference it made to him whether the trees of Gwaii Haanas, the contentious area, were logged. After all, I suggested, he would still have his work, his home, and an income. "Sure," he replied, "we'll still be alive. But then we'll be *like everybody else*." With that simple statement, he summed up a radically different relationship with Nature.

Haida Gwaii has been home to its aboriginal inhabitants since the beginning of time. The land and all the creatures that inhabit it represent their history, their culture, their meaning, their very identity. Without them, the Haida are no longer Haida. The Haida refer to whales and ravens as their "brothers" and "sisters" and to fish and trees as the finned and tree people. Isn't this just a different way of expressing E. O. Wilson's sense of kinship with all other life-forms that results from our common evolutionary history?

At a meeting with the non-Haida citizens of Sandspit, the forest industry town in Haida Gwaii, loggers insisted on their legitimate right to jobs and to their way of life on the islands. Finally, a Haida elder rose and said, "Most of you have lived here for only five or ten years. Our people have been here for thousands of years. How many graves of your people are there in Sandspit?" After a stunned silence, the answer came back: "None." The elder continued, "There are Haida graves throughout the islands, and that makes the land sacred to us. This is where we belong." The Haida opened up a new world for me. Their sensitivity to human interconnectedness with all life on their homeland, I believe, can give us an alternative to Western culture's narcissism coupled with an ecologically destructive worldview.

Years after I first encountered the Haida, I was at the airport at Sandspit talking to Miles Richardson, the charismatic president of the Council of the Haida Nation. Turning to a map of Haida Gwaii—which resembles a long triangle standing on its apex—Miles pointed out that with the preservation of Gwaii Haanas, the southern third of his land was now saved. The northeastern corner is Naikoon Provincial Park, while the northwestern corner was unilaterally designated by the Haida as Duu Guusd Tribal Park. With these three areas secure, much of the islands will be protected from

logging and development. "We want to declare the water around all of Haida Gwaii a marine park," he continued, "so the ocean resources can be managed according to Haida tradition."

Because the Haida were never conquered and never signed treaties with Canada, they believe they remain a separate, sovereign nation. Within a few years after contact with Europeans, more than 90 percent of the Haida died of smallpox. The survivors abandoned the dozens of villages spotted around the islands and now occupy only two—Massett and Skidegate. The present island population of two thousand Haida has been augmented by four thousand non-Haida newcomers. The Haida believe that a common sustainable future based on Haida respect for the land and its plants and animals is possible for all people. They want to cut back on logging and have already imposed their own fish management program, which has been accepted by commercial fishermen and most of the sport fishing lodges. Richardson told me that "ecological carrying capacity" of the islands must govern the way resources are harvested. If the Haida succeed, they could provide a model to the world of how people can live sustainably and in balance with Nature.

There are stories that are told, and there are those who tell them. Where the spruce run to meet the sea on the wooded shores of the Queen Charlotte Islands—Haida Gwaii to its native people—off British Columbia, the silent and fallen totems tell the story of the Haida Indians. Legend held that the Raven himself had created these islands when he became tired of flying and dropped the stones he was carrying. From ancient times it had been the custom of these people to see the raven and the eagle, the whale and the bear, as their brothers and sisters. They had named this land the *Islands of the People*, and their living places *People-wish-to-be-here*, *Raven-house*, and *Thunder-rolls-upon-it*. Everything—the rock, the cedar tree, the raven, the salmon, the deer, and man—was a part of the life force, the Spirit. For as long as anyone could remember, they had understood that nature required of them a reverence for its basic law, that no one take too much. With this wisdom, they had created for themselves an abundant life rich with the images of their fellow creatures.

In the late 1700s, the seafaring traders from Russia, Spain, England, and America appeared. One by one ships began to find their way, following the warm Japanese current to the misty Pacific coast of Canada. There they met the Haida, who quickly saw the advantages of the blankets, the metal tools, and the guns offered them by the traders. Admirers of beauty as well, they valued the colors of the glass beads and especially the silver coins. These they heated and shaped into designs showing the bear, the beaver, the killer whale, the shark, and the raven. In turn, the traders admired the skins of seal and otter worn by the Haida, and soon a steady trade grew between the two.

The traders soon discovered that across the Pacific they could trade the skins in China for spices, silks, and fine sandalwood boxes. Once back in their homelands, they found that by selling furs, spices, and exotic goods they could become rich. The Chinese were also happy, for they grew rich as well from the profits of their trade. And on the islands of Haida Gwaii, the Haida grew proud of their new command over nature. They hunted with guns now, and with metal they created grand gestures of their wealth and huge family crests on great totems.

In time the traders came less often to the shores of the Northwest. The younger chiefs had ignored the warnings of the elders about taking too much, and the pelts of otter and seal had grown scarce, leaving the Haida little of value to trade. And there had been violence, first against the traders, and then among themselves. Though they were less eager to trade now, the Haida had lost their choice, for sometimes the traders from the sea simply took the pelts by force, leaving many Haida dead. Sadly, diseases brought by the visitors also left nearly 90 percent of the Haida sick and dying.

And so the people of Haida Gwaii, their totems etched proudly with stories of their families and legends of the raven, the eagle, and the whale, were driven from the home they had known since ancient times. And today, if you were to ask the seafaring traders what happened to their old trading partners, they would probably tell you that it is no longer possible to trade with the Haida, for the Haida

are not what they once were.

Ask the Haida what happened, and they might say, "The white man came, and now we are few and live farther north. We work in the fish-canning factories and carve wood to sell to the tourists. We struggle to protect our spirit land from the loggers, and we are moving back to what is ours and what is sacred to us."

And if you were to ask the totems the story, you would see in their fallen and decaying faces the truth of the ancient Haida law. And you would see in the cracks of some totems the force of new life—young trees sprouting. Along the shore you would see the curving back of the killer whale, hear the cry of the raven, and find that wild grasses and spruce still run to meet the sea. And if you were willing to wait and listen and watch, you would discover something that had been there long before any man ever came: the spirit of life itself.

Haida Gwaii | *The Queen Charlotte Islands, British Columbia, Canada*

Home to the remaining Haida Indians, the Queen Charlotte Islands lie eighty miles off the British Columbia coast and several hundred miles north of Vancouver Island. The Haida now reside on the northern part of the islands. My explorations for these images were made by sailing vessel in May 1989. The main site for these photographs is located on Anthony Island at an abandoned village called Ninstints village. The other site is called Skedan, located on Louise, a small island a little farther north. Both sites have been abandoned to the forest since the late nineteenth century. Recently UNESCO has designated the Anthony Island site as a Cultural Heritage site protected by law.

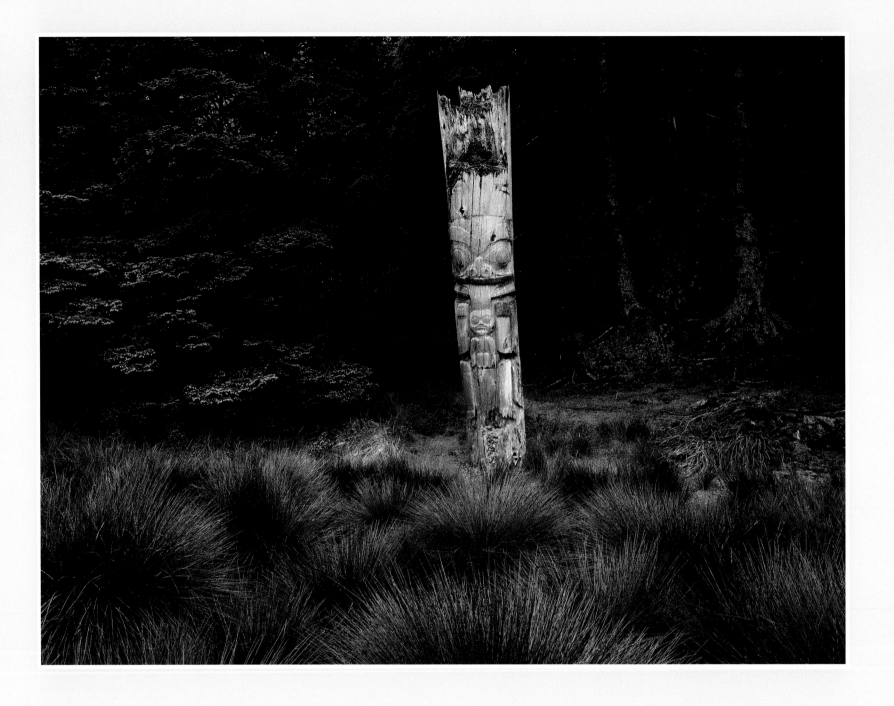

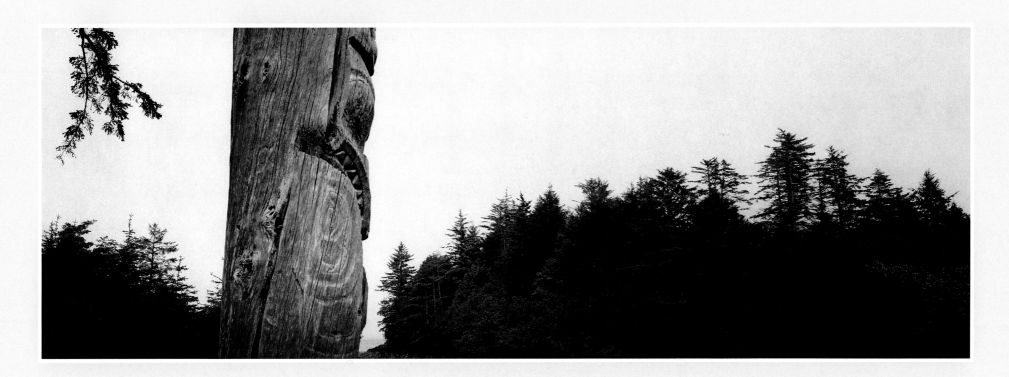

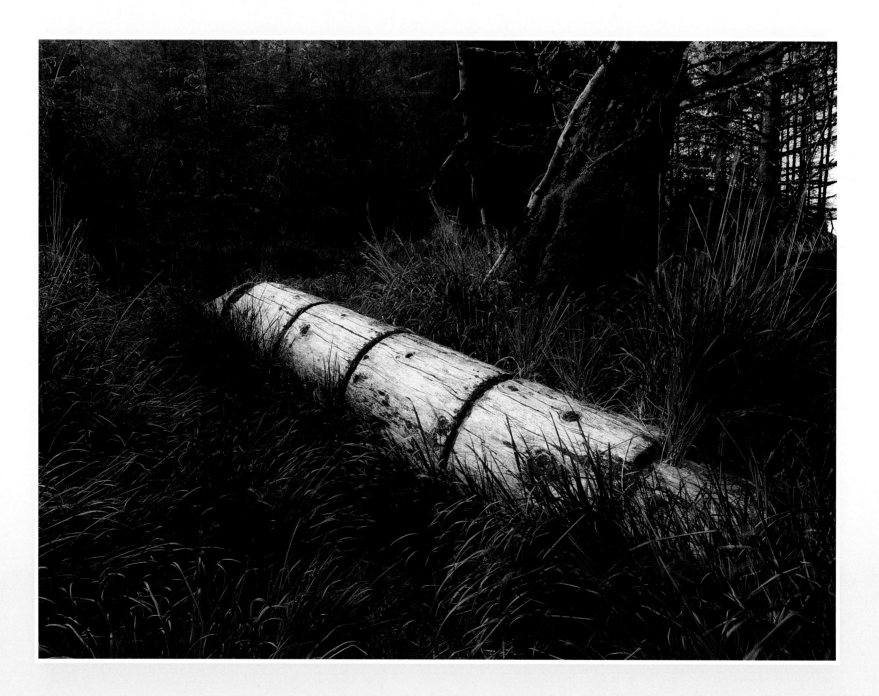

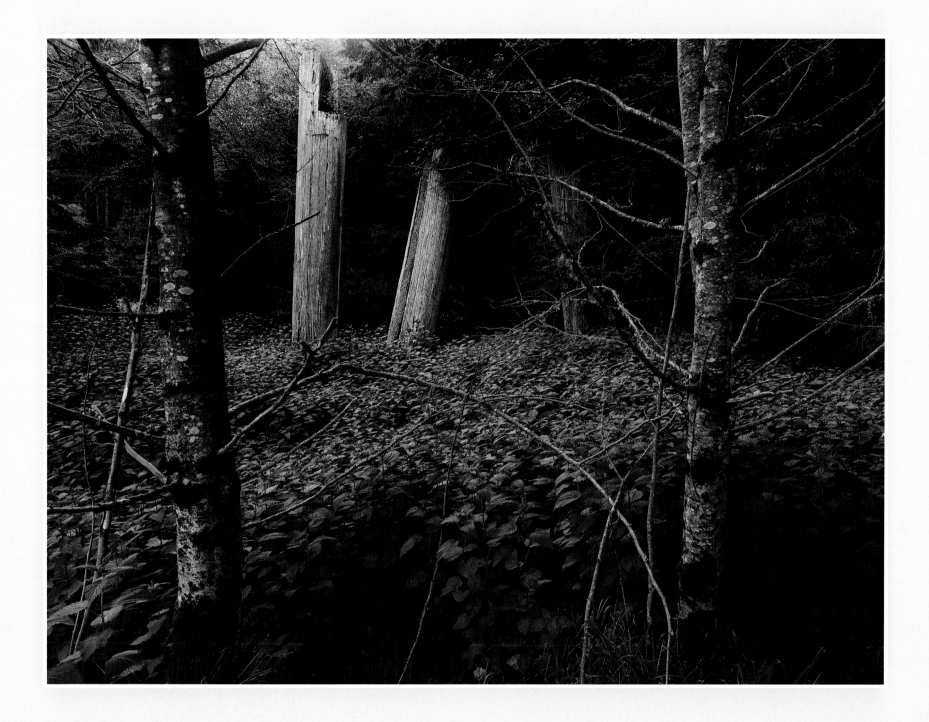

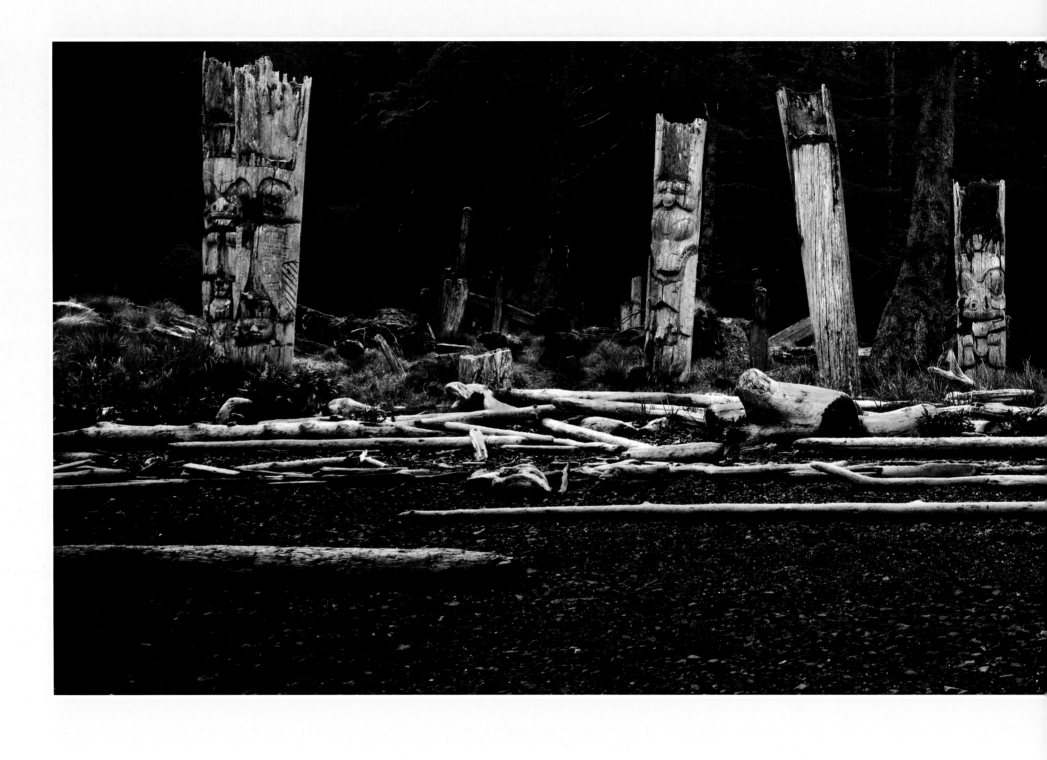

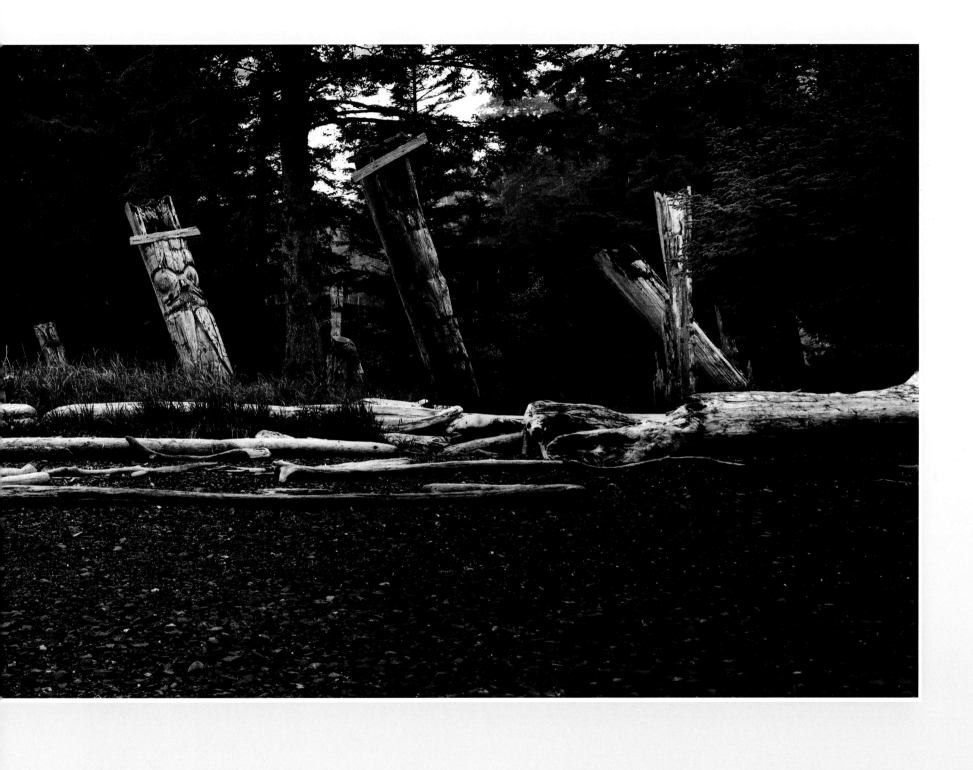

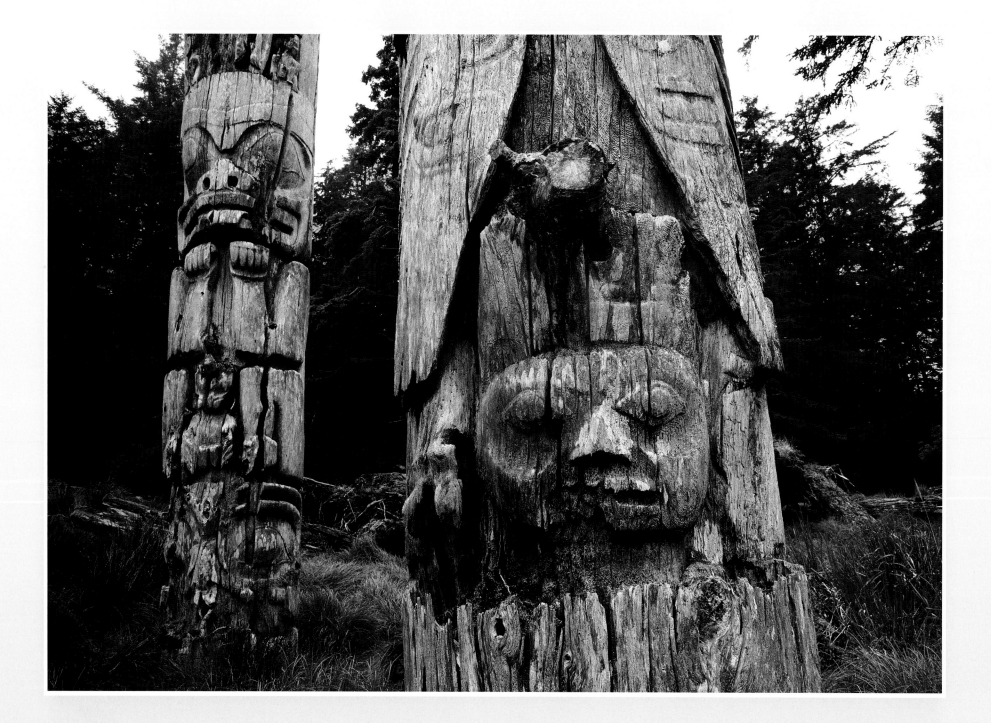

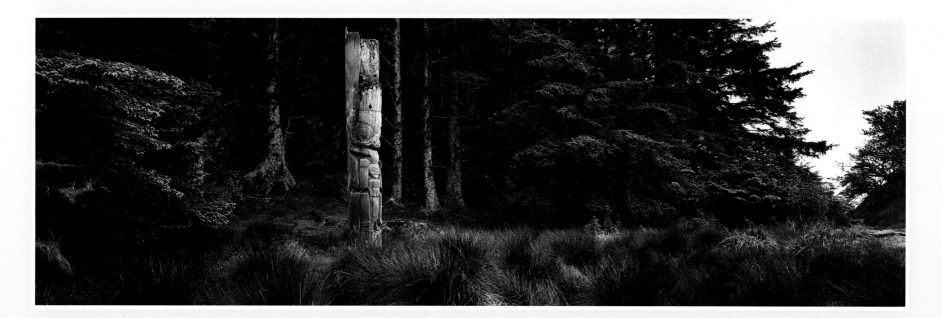

Rapa Nui

Easter Island

A VIEW FROM THE NAVEL OF THE WORLD

Joan T. Seaver Kurze

As a collapsed and crumbled society, Rapa Nui is not unique. We are reminded of other events in the historical record when individual and collective human hubris helped lead to destruction—early Chinese dynasties and the Roman Empire come to mind. But the fallen icons on Easter Island send a particularly threatening message that applies to us all.

Stories from island descendants tell us that somewhere in the late seventeenth century, the Rapa Nui began a long civil war which wiped out their oppressive rulers. The revolutionaries then turned on one another, and in the savagery that followed, they burned fields and abandoned their agriculture in favor of a war that flared intermittently for generations. Legends say that cannibalism was practiced over the last two hundred years, for the greatest insult to an enemy lay in eating him. Because they also consumed irreplaceable natural resources, especially their forests, the Rapa Nui experienced a disaster that all but extinguished their culture.

Westerners still struggle to believe that Stone Age Polynesians were capable of constructing the spectacular stone-faced *moai*, but archaeologists have documented their creation by the artisans of this complex Stone Age society. The Rapa Nui for centuries were able to organize themselves to carve nearly 1,000 immense stone torsos from the rock on their island. Once completed, without modern technology, these giants were successfully moved across rocky terrain and finally raised up onto their *ahu*, or outdoor stone altars.

The immense icons enforced the power of the persons they represented—former rulers. It is said that their faces were brought to life by creating eyes to sit in their sockets, leaving the guardian statues to gaze steadily on the villages below. When the first Europeans arrived in 1722, the statues were still standing, but as the war continued, most of the statues were toppled. Ravaged by their own savagery to one another and by diseases introduced by visitors, the Rapa Nui saw the remaining bearers of their culture carried off as slaves to South America. By the early 1860s the remnant of this once vibrant Polynesian culture—very old people and young children—had lost touch with its heritage.

As a cultural and environmental mirror, Easter Island leaves us a haunting image. While the eroding petroglyphs and fallen stone giants of this defunct society lie isolated on Easter Island, we can ignore only at our own peril the message they offer of the limits of man and nature.

Here on the edge of an extinct volcano, I can feel the primary energy of life—earth, wind, fire, and water. Orongo, an altar of stone poised a thousand feet above the sweep of endless blue, is a place of sanctuary, for me peaceful beyond anything else on the planet. Visually it is the end of the Earth—and the beginning. Here I can contemplate the curve where the sky meets the sea, the horizon, the crack of infinity.

If you come here to Easter Island, in your heart you will sense that we need more time with what is timeless. Here in the silence, you will hear the din of your everyday life. You will come to understand just how much of your attention you have fed to your machines and your belongings—the car with its payments, the dead battery, the driveway full of snow, the darkroom chemicals to check, bills to pay, voices on the answering machine, identity lodged in possessions, considerations. As the echoes of civilization subside on this lone promontory, your identity with what you want and what you own will gradually vanish. If you do not try to hurry the process, the mosaic of what we call the self will begin to dissolve. What may follow is a nakedness of the spirit, a pause, a void when fear may rise within. Without any vestige of material identity, who would any of us be? What are we? The answer, though elusive, lies somewhere beyond the burden of comforts. When the old formula for self no longer works, I find that I must reach for the basic spirit of life.

I travel here because at this very spot, perhaps like no other on Earth, I confront a paradox. Here humans extinguished most forms of life. Yet here on an island where the population self-destructed, there are signs of the struggle for rebirth, and here I find peace with nature.

If you will look at the landscape of Easter Island in the silence, you will see written on it the record of a dark and enduring disregard for the spirit of life. On treeless, grassy sweeps that decline toward the horizon, the great faces of the stone statues sit with their backs toward the sea, indifferent to everything except the puzzle to which some say they hold the answer. Their colossal faces gaze toward the people, as if to ponder their mistakes, yet the expressions chiseled in stone say nothing of the destruction they witnessed.

In the history of Easter Island lies a chronicle of human society coming unraveled. Here was a culture, a government, a language, and art forms unique to human experience. Now it and most of what supported it are gone.

A succession of European visitors chronicled the story of a culture rich with resources spiraling ever downward. The first to come was Jacob Roggeveen, who arrived in 1722 and named the unlucky place. Civil war had already begun on what seemed to him a paradise. Captain Cook visited later in the 1770s, finding a war still underway, then Jean La Perouse in the 1790s, who left the inhabitants goats, lambs, and hogs to replenish devastated food supplies. In 1872, the crewman Loti on a visiting French frigate wrote of the place as an immense ossuary, with skulls and bones everywhere. Cruelty apparently had become a tradition, and by the time

of Loti's visit, all the completed statues had been toppled.

History here holds a number of mysteries. We know something of the people, the powerful long ears and the short ears they enslaved. Fragments provide a rich abundance of clues, and stories were passed along from generation to generation on Easter Island. The trees here provided the materials for boats, fires, housing, and the movement of the giant statuary *moais*, but eventually demand outstripped supply.

According to legend, a revolution in the late 1600s led the short ears to rebel against their oppressors. Once the long ears had been overthrown and order destroyed, conflict followed among the tribal groups of short ears for over a century. As the oppressed rose, cruelty became the prevailing ethic. Agriculture dwindled, perhaps because it represented the work formerly done for oppressors. The short ears stripped the natural resources—the trees, the fish, and the food. Eventually the wars among the survivors descended into cannibalism.

In 1862, Peruvian slave traders carried away several thousand people, including the last king, and put them to work on the ranches and in the haciendas of aristocrats. Most of them died within a year. The remainder brought back smallpox, which ravaged the few left on the island. In 1888, Chile took political control of the few hundred survivors, the remnant of some eight thousand or more original Easter Islanders.

Much of the history of any place lies in what the people there have done with nature. Once man turned against man, it took roughly two hundred years for Easter Islanders to destroy the natural forces and what those who had come before them had created over millennia. They all but vanished, and the momentum of their choices has since stretched forward a century. In the silence of Orongo, with the fate of Easter Island spread before you, you cannot help but see what happened here as a microcosm for what the Earth faces. How ironic, for on top of all those layers of death and destruction sits a sanctuary, and with it, the possibility of renewal.

Like the people of Easter Island, we face choices, primary among them whether we will learn to get along with one another, and more, whether we can recapture a consciousness of nature, to see in nature the final definition of human identity. If Easter Island offers us the metaphor for Earth Island, perhaps we will come to understand that we have lost our humility, and with it we have come close to losing the margin of error for all life. On Rapa Nui, the long tradition of man finding definition in self rather than in nature appears starkly in the legacy of treeless sweeps of hills and idols of men shaped by men. And on Rapa Nui, the landscape reminds us that humans are, after all, only one species among many.

If the mind of man has proven godlike as a power, here it has required a price—the desolation of Eden. And now we are come round again to ask ourselves who we are, for who is any of us without nature? The answer lies in the heartbeat of the Earth, if only we can learn again to hear it.

Rapa Nui | *Easter Island*

Easter Island, located in the eastern part of the Pacific Ocean some 2,200 miles from the South American coast, is fifteen miles in length and a little over seven miles wide. The exact origin of the early people is still disputed, but the influence definitely came from Polynesia. Today Easter Island is administered by Chile. All of the rock statues, or *moais,* were carved from the rock of the sacred volcano, Rano Raraku. The moais are scattered throughout the island, having been mysteriously transported to their locations.

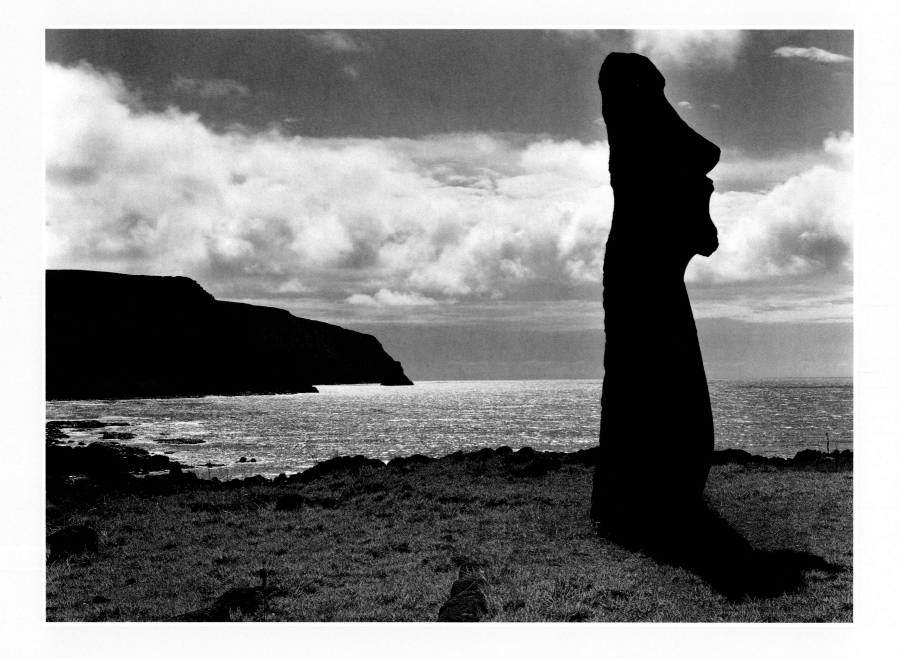

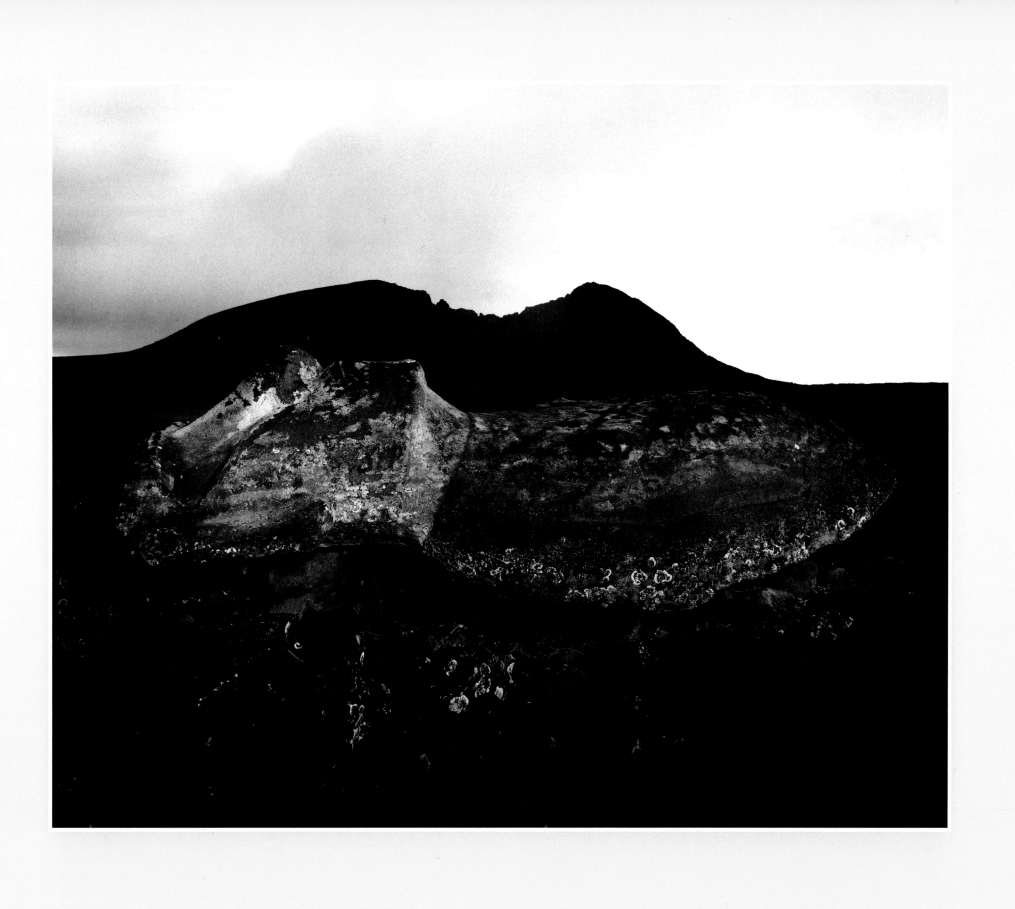

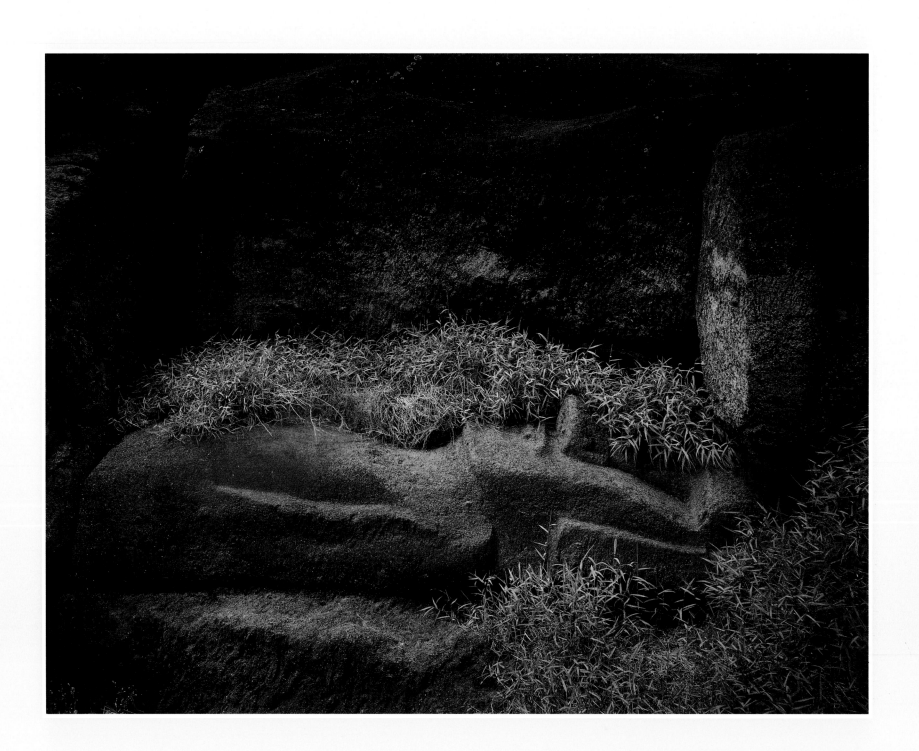

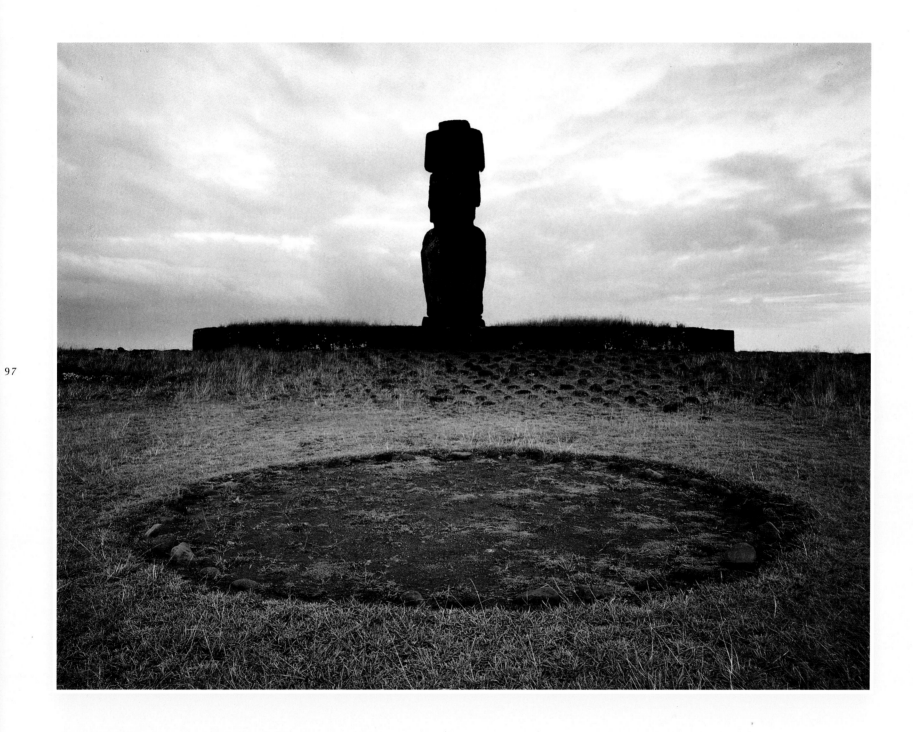

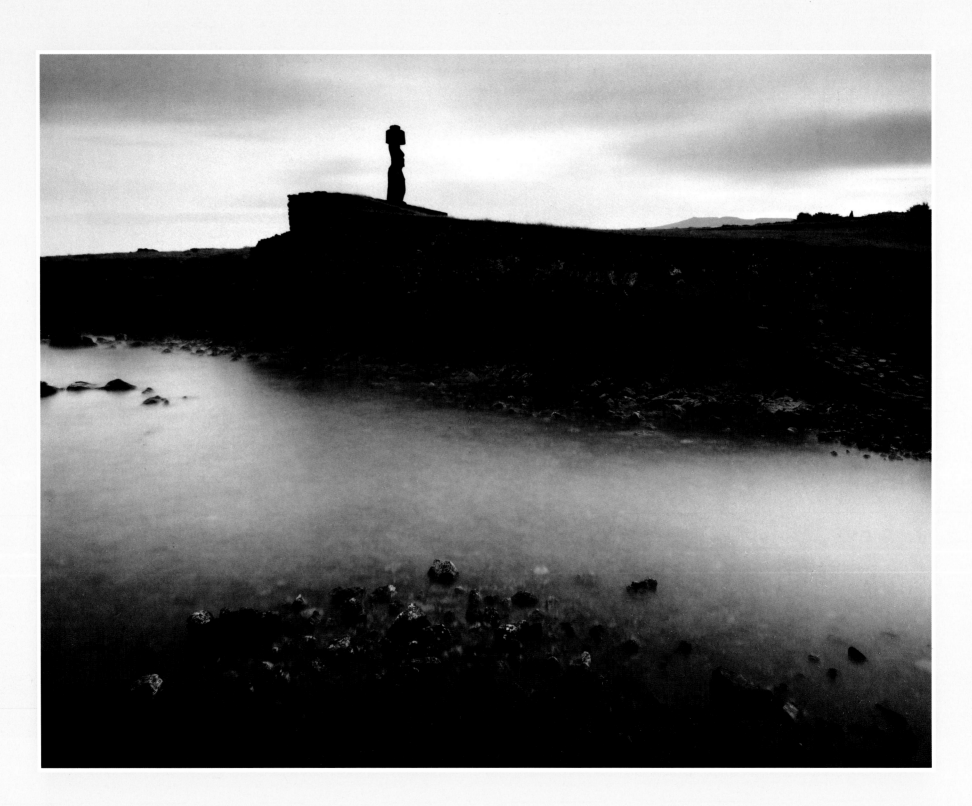

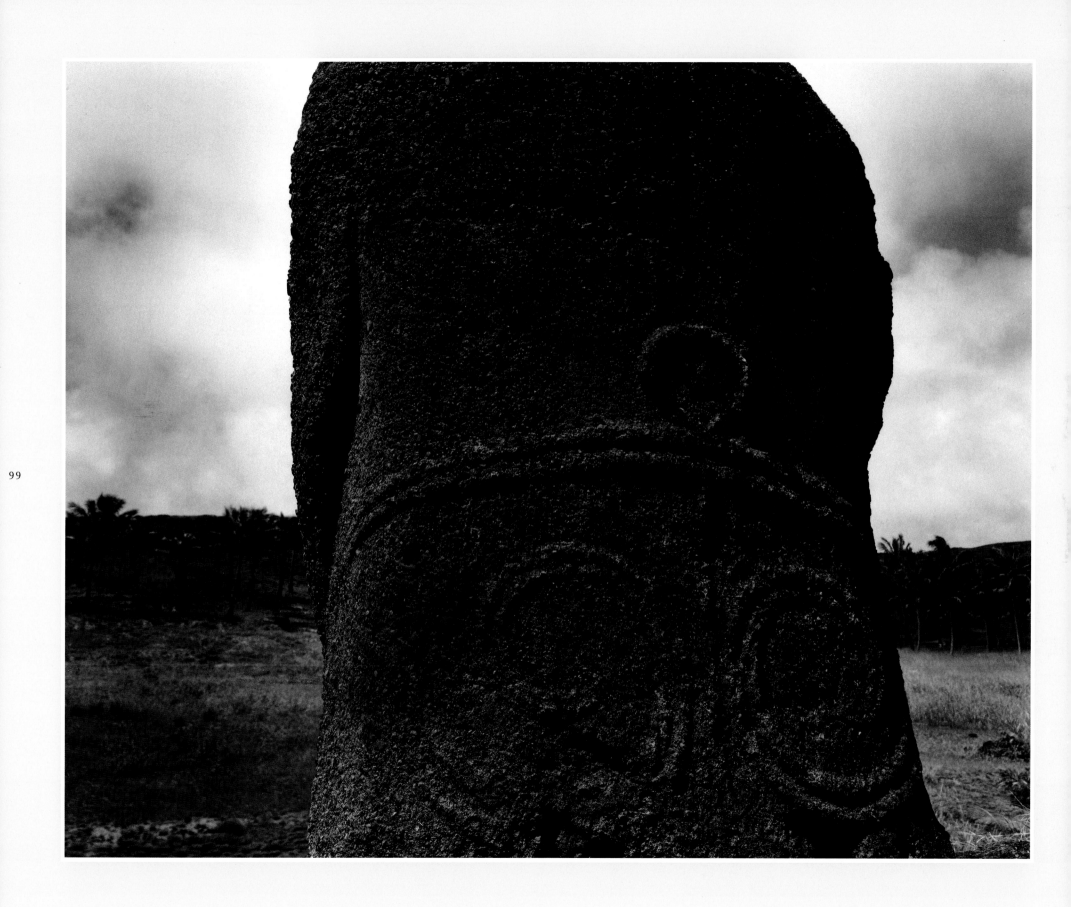

The Kingdom of Siam

Thailand, Burma, Sri Lanka, and Cambodia

THE OWNERS OF THE LAND

Eric Crystal

Since ancient times, the religions of Southeast Asia have held that the forces of nature and the spirits of ancestors carry special significance in the daily lives of the people. Although long submerged by the intervening layers of Hindu, Buddhist, Muslim, or Christian thought, belief in these mystical forces continues to shape the hopes and fears of millions on the subcontinent.

In Southeast Asia, humanity invests nature with superhuman spiritual powers. While Western society has steadily evolved toward a secular set of beliefs, village farmers in Southeast Asia for five thousand years have maintained a spiritual sense of the staggering power of nature. In the rumbling clouds atop the mountains, in the flooding river, and in the magic that moves the rice to ripen, the powerful evidence of spiritual forces continues to appear. These ancient belief systems turn human attention toward the landscape that supports human existence, for there lies the energies from which life itself springs and from which death can suddenly beckon.

Traditionally the Southeast Asian worldview seeks an ecological equilibrium, one that appeases the gods of nature and provides continuity with the past. Here humankind expects the world of the temporal to defer to the world of the supernatural. Whether it is cataclysm or a good harvest, the individual looks for the gestures of powerful natural gods who govern life itself, who send the slow but ever-so-sure cycle of life and death spinning toward eternity.

The souls of recently deceased kin are also treated with special care, for the spirits of ancestors still carry great influence in the daily operations of life. Although ways of reckoning kinship vary widely in Southeast Asian communities, kinship usually includes relatives both living and dead. Because ancestors are believed to maintain an interest in family affairs and to exert an influence on daily events, Southeast Asians spend considerable energy ensuring themselves that the influence of these ancestors is benign. On ceremonial occasions, they always furnish ancestors with remembrances, often in the form of rice and meat offerings. When ancestors appear in dreams, they are thought to cause everything from everyday illnesses to fatal accidents. Angered or displeased by neglect, they can visit sickness and poverty on descendants who mistakenly ignore them. On the other hand, the spirits are also thought to ensure healthy offspring, and if the supplicants are loyal and generous in their offerings, they may even find themselves rewarded with wealth.

Even today the powerful rice goddess of the prehistoric past is wooed each year in hopes of bringing prosperity to the community. In traditional villages, special offerings are made to agricultural spirits before the first seed is sown, when the field is weeded, and as the rice nearing harvest begins to turn the fields to gold.

In every contemporary Southeast Asian culture, be it Buddhist, Muslim, Hindu, or Christian, this strong undercurrent of indigenous religion persists. Whether it is the goddess of rice, the spirits of the forest, or the supernatural beings thought to dwell in the vicinity of great banyan trees or in the depths of freshwater springs, the people bring offerings, for these spirits are known to be the original supernatural "owners of the land."

101

Southeast Asia is like a man who keeps two kinds of time. In the press of hurrying to keep a business appointment, he may turn quickly to his digital watch, but in matters of the spirit, he will consult the slow trickle of sand gathering in a crusty hourglass that has no hour, no date, and no century.

In the cities, the concrete and glass echo the roar of busy motorbikes and trucks while the smog collects about the serene image of the Buddha. In the tropical forests, however, life is slow, time moves reluctantly, and spirits hold their ancient forms.

Before the images of Hinduism and Theravada Buddhism came to the humid jungles, religion here did not trace itself to a human founder. Belief sprang from a sense that in the mountains, the trees, the rivers, and the swamps lay the original and powerful gods. Everything of the Earth had the possibility of spirit. Today, after several thousand years of new gods attempting to take their place, those same primal spirits linger in many hearts, for here people invest the trees, the creatures of the Earth, and the events of everyday life with spiritual significance.

For some, life itself is felt to turn on having the right *katha*, a talisman from the sorcerer that is promised to keep malevolent ancestral spirits at bay or to appease the forest demons, the *neak ta prey*. Another may speak of a magical potion that makes his skin resist penetration, yet he will wear a *katha* shaped as a miniature Buddha. Some believe that tattoos ward off evil spirits, while for others, enduring great physical pain may demonstrate spiritual progress.

Although the magic represents the hope of warding off or controlling the causes of trouble, the Buddha charm suggests the need for a durable patience toward a fate we share with all living things, one only timeless reincarnations can reveal. There is no contradiction here, for man's power and helplessness form an ageless paradox.

Ancient spectacles in this land draw people from across the world. Temples and statues that rival anything constructed by the human hand sit like time capsules of the spirit, there for us to examine for the lessons of the past. Some say that the grandest of them all is a complex known as Angkor Wat.

In its sweep of stone and five rising towers, the great Angkor temple embodies a seduction—the seduction of grandeur. It is hard to grasp that the temple complex represents man's longing to escape mortal limits. A Khmer king, declaring his new role as *devaraja*, or God-King, began work on the temple in order to place himself alongside the Hindu god Vishnu at the center of the spiritual universe. While the animated crowd of Hindu deities speaks of divine influences, the cascade of stone figures tells us nothing of the king, now long forgotten.

Astride the platforms laden with Vishnu and Shiva, the immense Buddhas sit, late arrivals constructed atop the layers of Hinduism and animism earlier captured here. The ancient messages of Shiva, the destroyer of the world, appear dominant in recent times in Cambodia, where the people have witnessed a frightening re-creation of autocratic power. In the midst of civil war and further ruin, Vishnu no longer appears able to protect the people, and Buddha's enigmatic smile holds only a hint of hope for an end to the

desire that causes the suffering.

At Angkor Wat, a forgotten king's pride once enslaved thousands and ruined a rich culture. The complex system of moats, walls, and spiraling towers is now invaded by the jungle and aswarm with bats. Wherever they rise in the steaming forest—the ritual burial mound, the elaborate temple, the soaring Buddha—all speak of a yearning to turn human matter into divine energy, into spirit. Whatever our myths, gods, and goddesses, it is as if the history of man repeats a single message, one that says: Powerful forces beyond man shape human destiny. When we listen well to what these forces tell us and follow the path of kindness toward all things, we move matter toward spirit.

Like the other temples of Southeast Asia, Angkor Wat reminds us that grand human dreams endure only when they embrace as well the force that drives the jungle vine.

The Kingdom of Siam | *Thailand, Burma, Sri Lanka, and Cambodia*

Theravada Buddhism is the cement that ties these Asian countries together. Each country was affected by Buddhism as it spread from India east into Asia. Many of the countries incorporate local animistic folklore beliefs with Buddhism. These photographs were taken between 1986 and 1991. The ruins date from the period when the local people were involved in Theravada Buddhism.

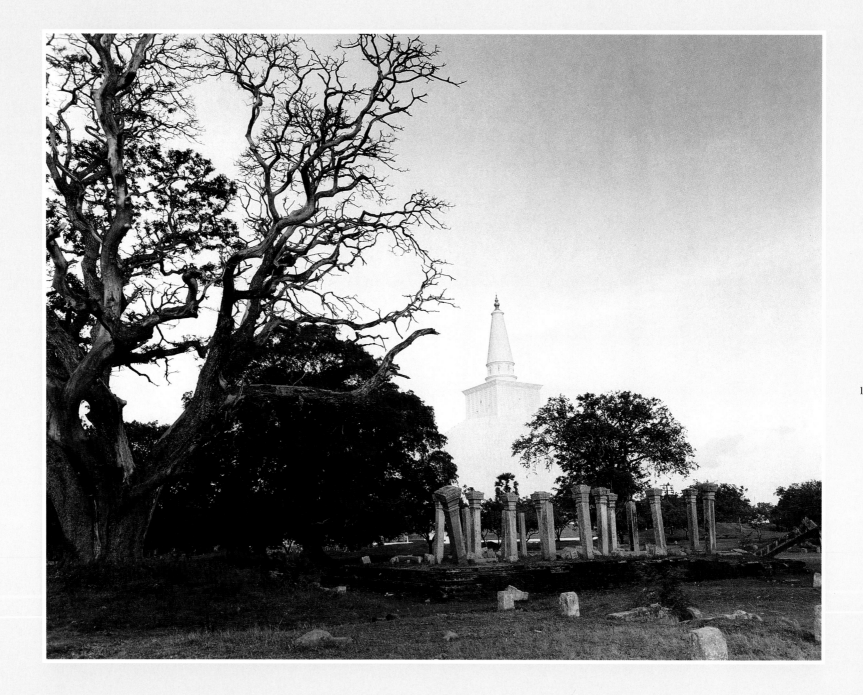

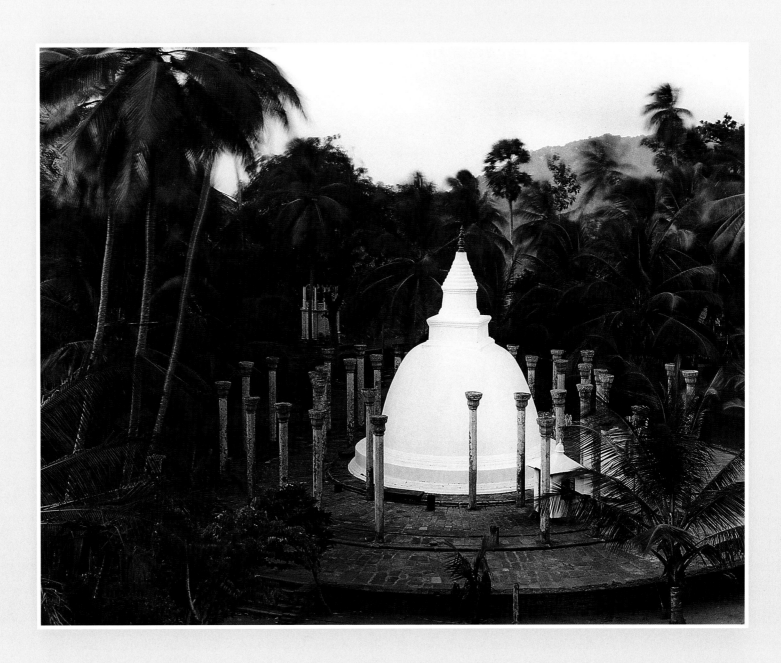

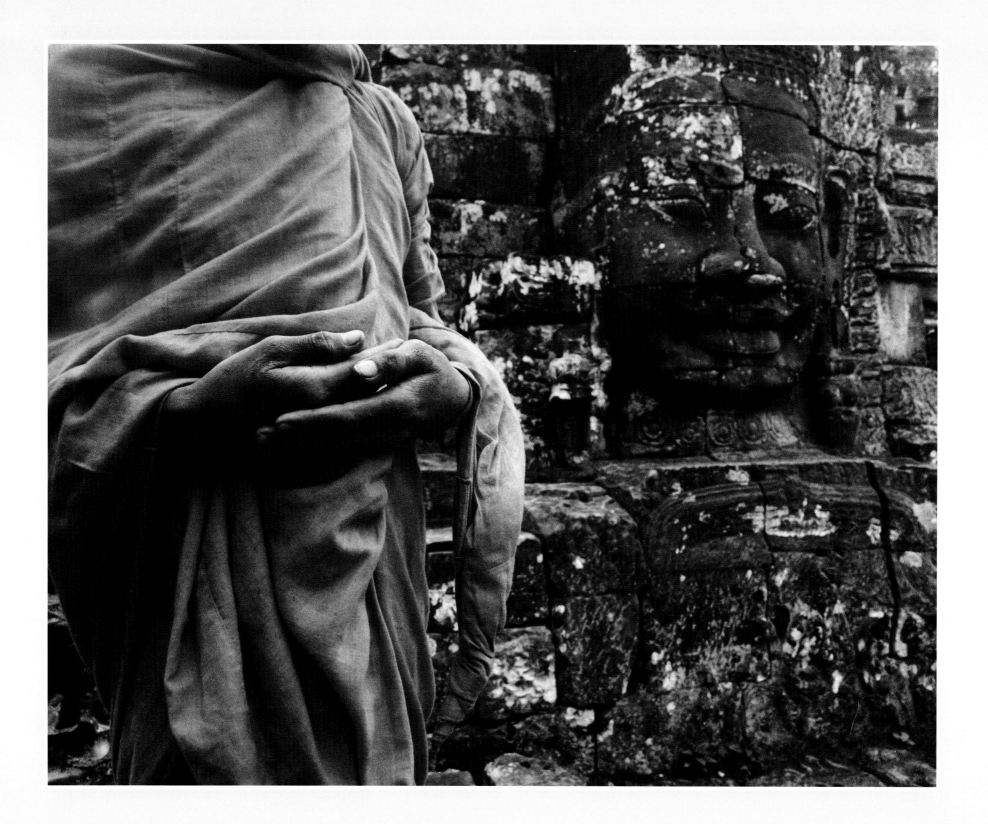

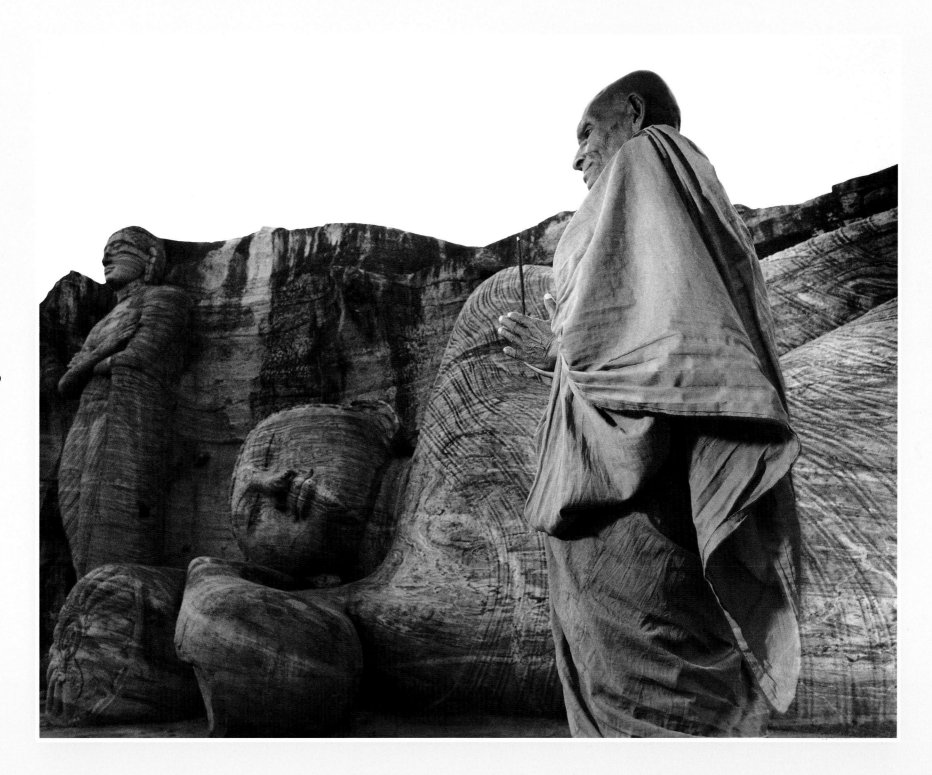

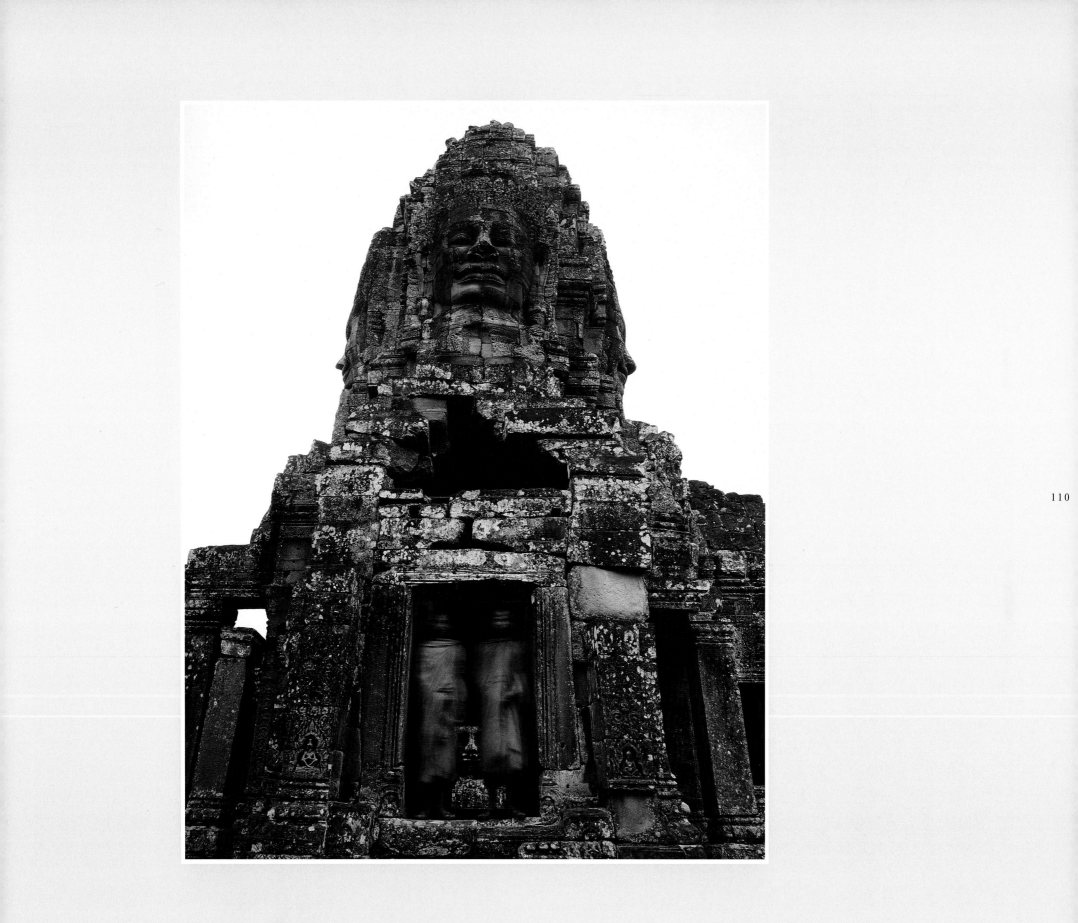

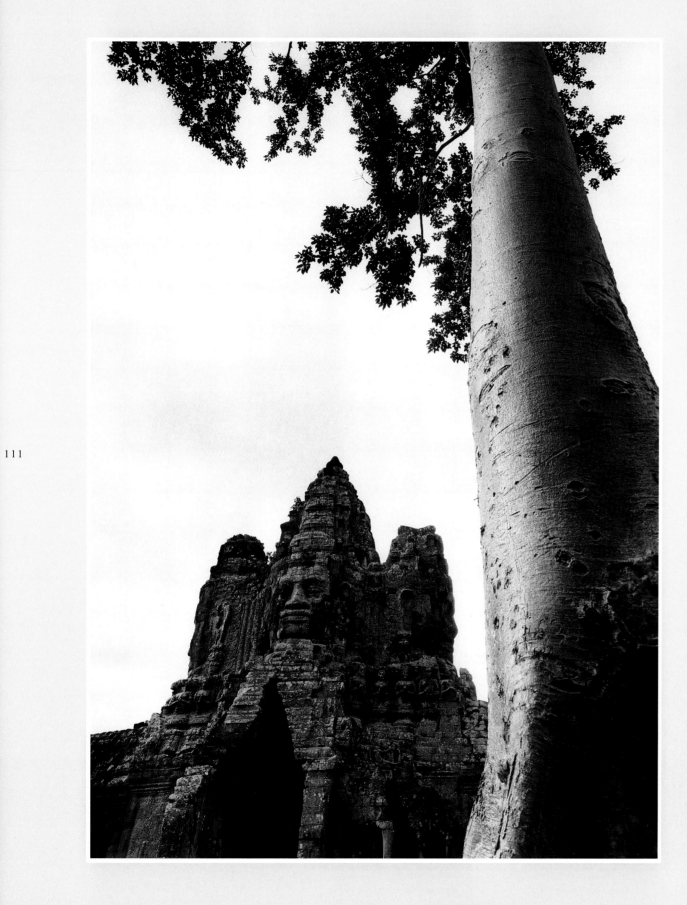

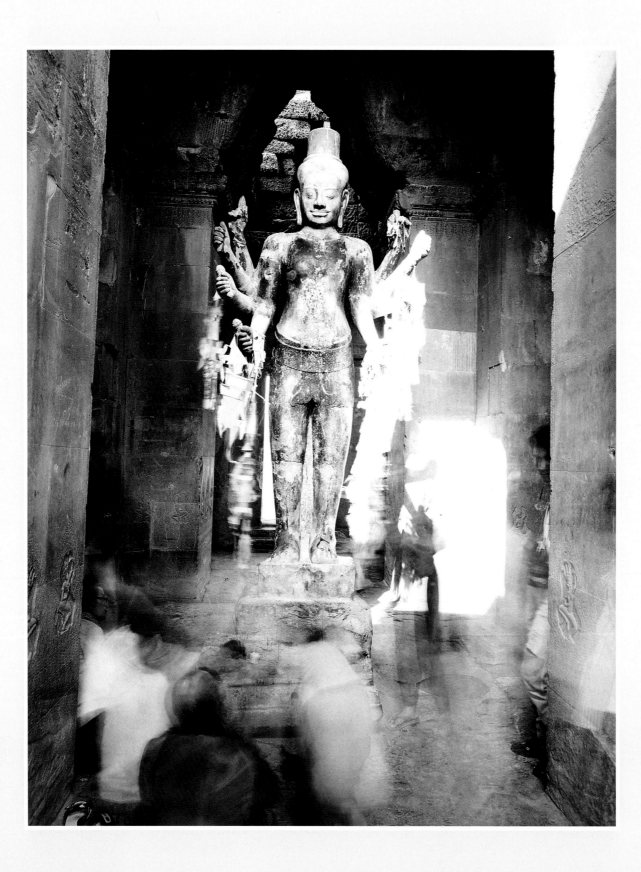

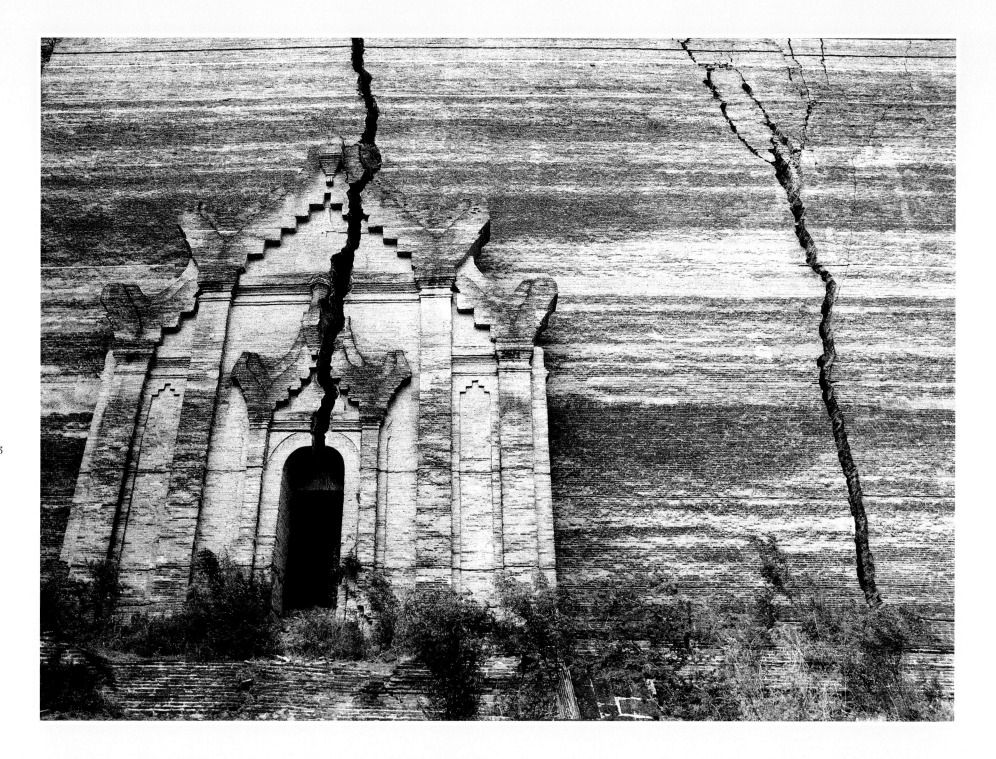

113

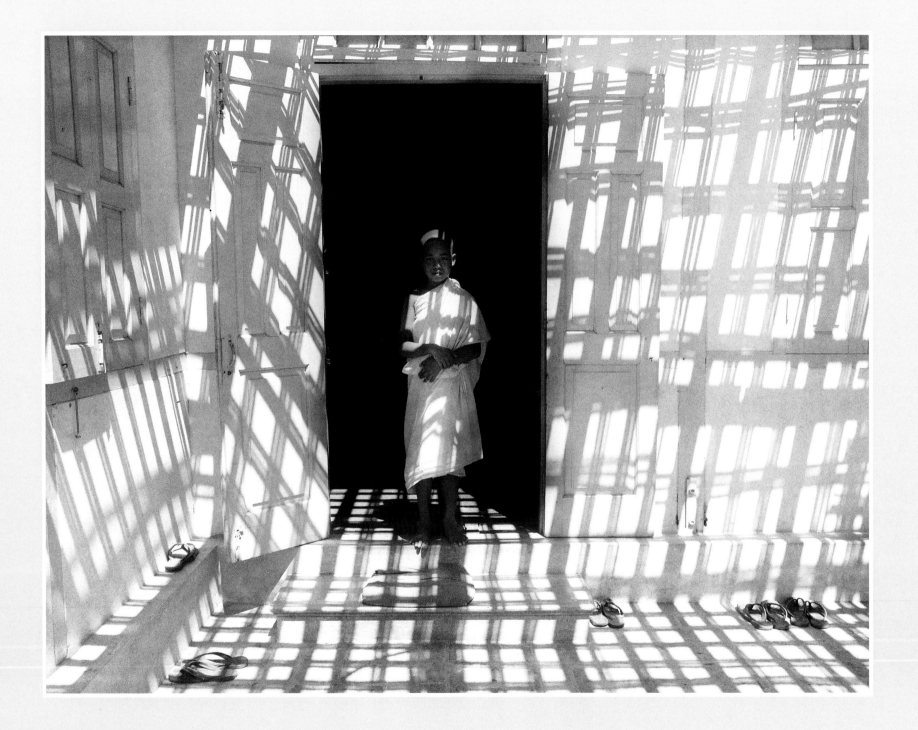

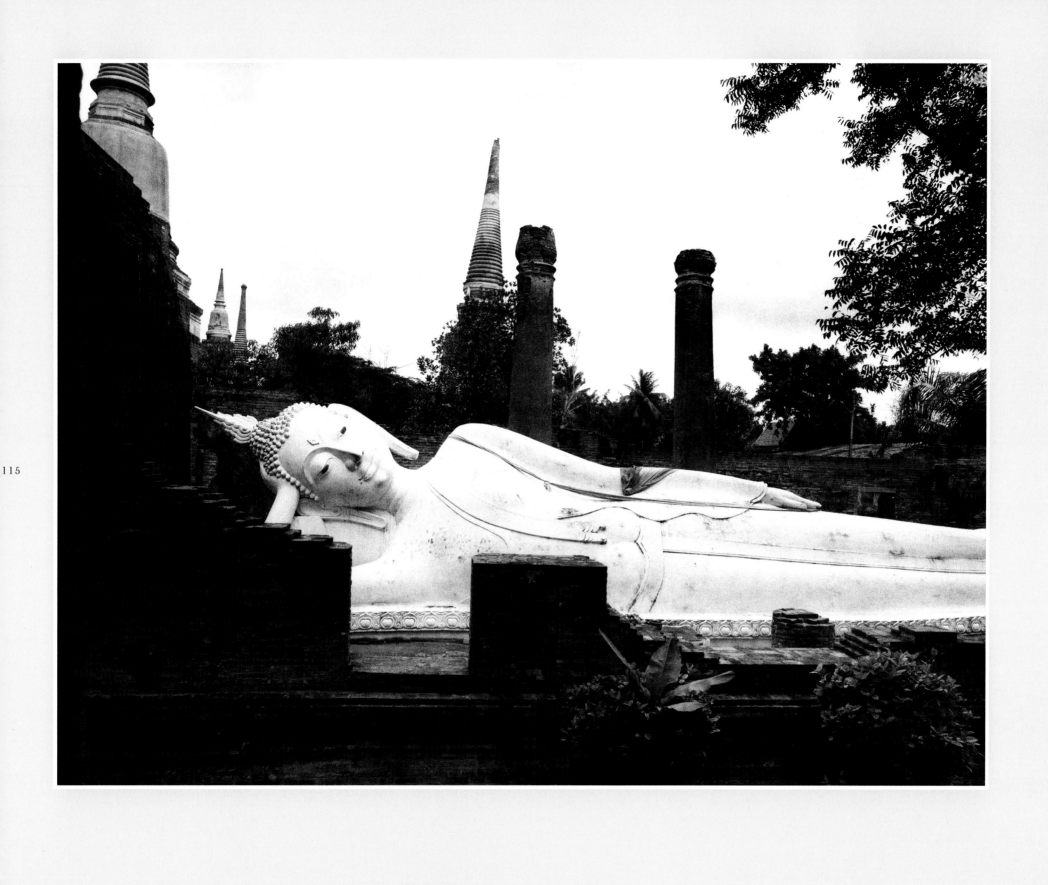

115

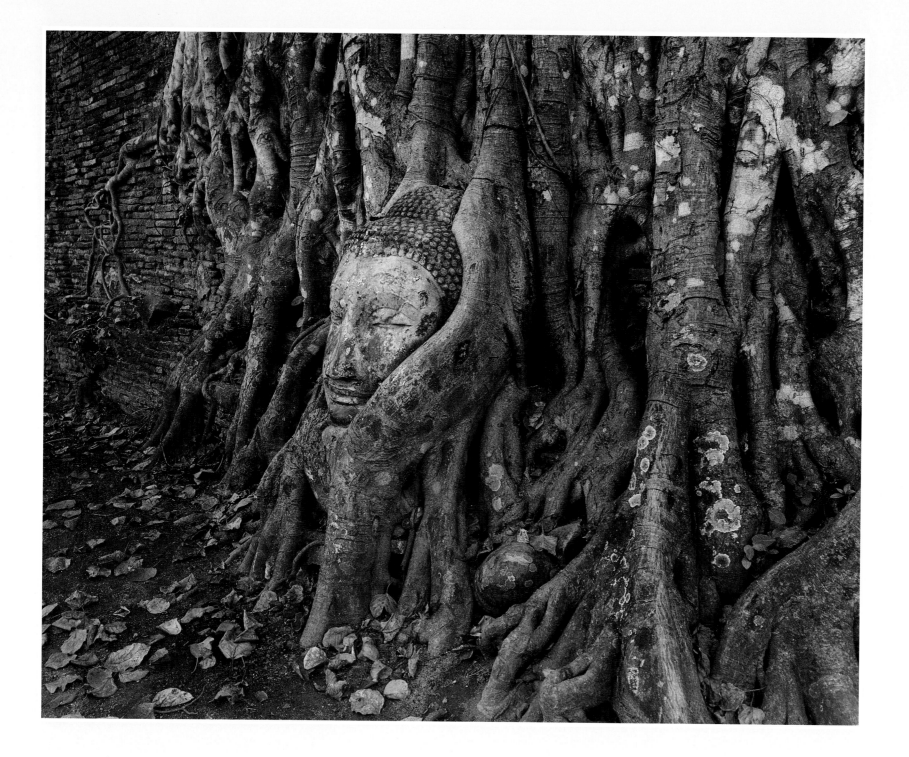

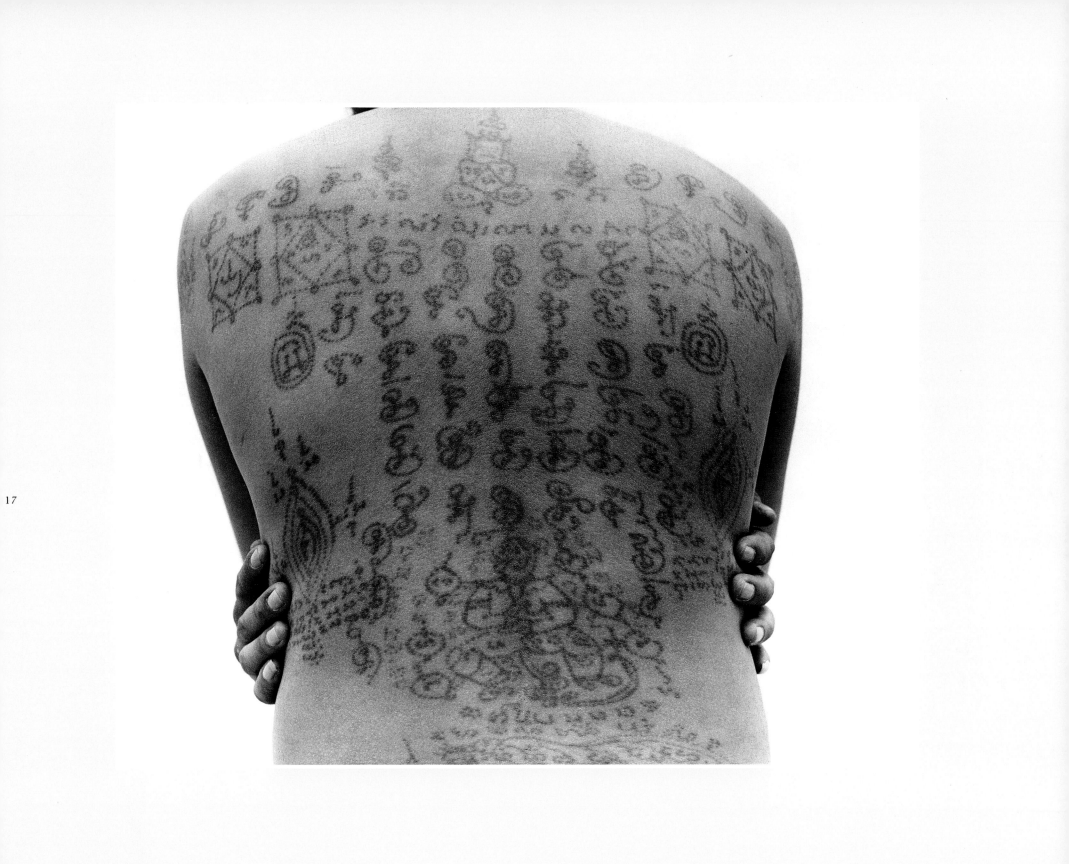

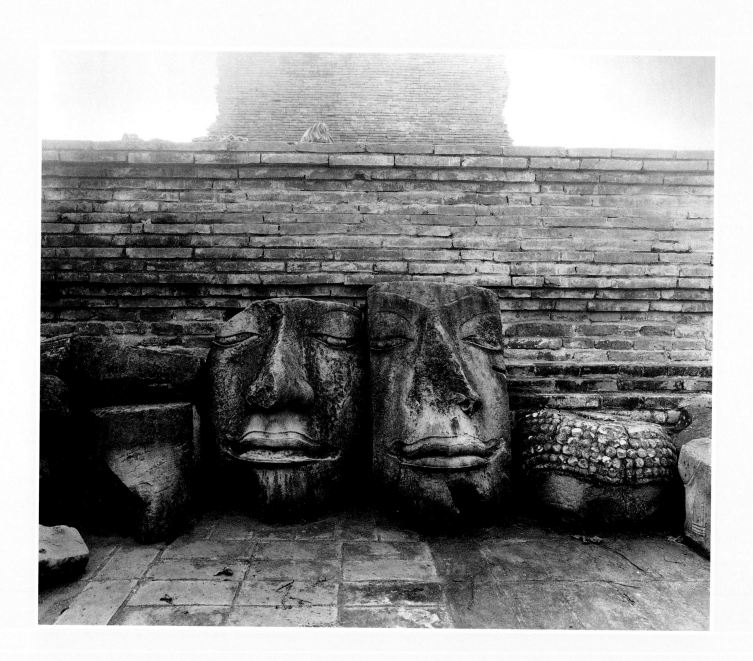

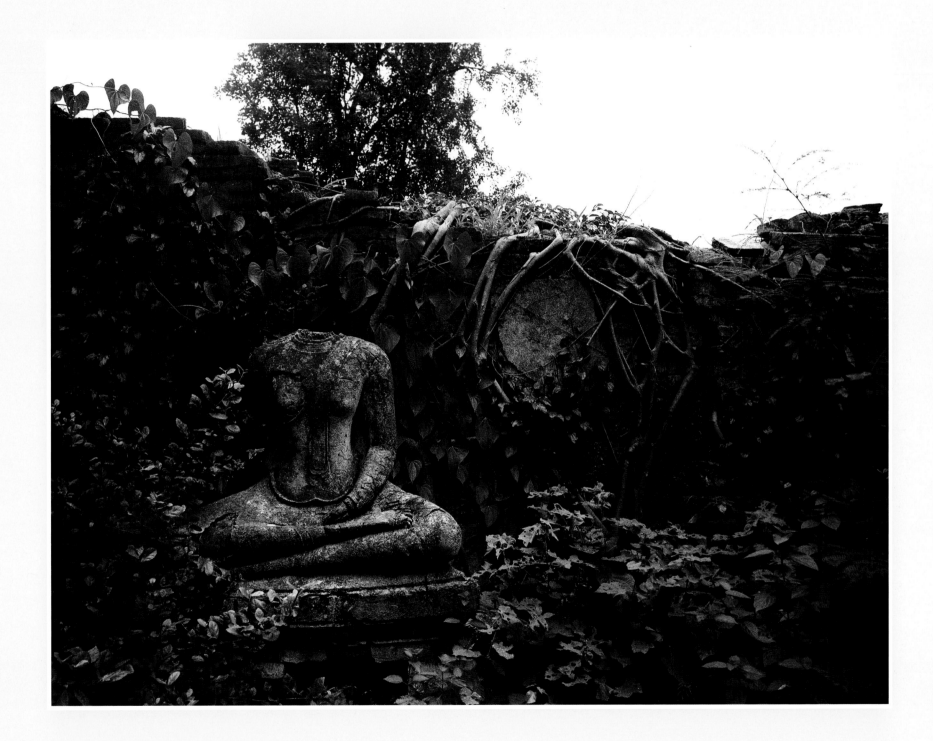

PHOTOGRAPHER'S NOTES

Throughout the many years it has taken to complete these photographs, I have used a variety of film, paper, chemistry, and camera formats. There is no perfect camera, so I have spent a lifetime exploring the possibilities. Many of the images in this book were taken with either a Pentax 645 or a Pentax 6x7 medium-format camera. Most of the pictures from the Himalayas and Easter Island were taken with a 4x5 large-format camera. There are, however, a few 35mm images scattered throughout the book taken with Nikons or Leicas. I have used a variety of films, each chosen for how it reacts to specific lighting conditions. Mostly I have used AgfaPan 100 and Kodak T-Max 400 film. However, without a doubt the true magic of a black-and-white print comes forth in the darkroom. I wish to thank my teacher and friend, the late Ansel Adams, for passing on the knowledge. It is a great privilege to be able now to pass it on to others.

CHRIS RAINIER documents the last of Earth's wilderness and indigenous cultures. His photography explores the places where ancient cultures were once in balance with the forces of nature. He has also documented the survivors of the Killing Fields of Cambodia, covered the Ethiopian famine of 1985, and photographed the horrors of civil wars in Sri Lanka, Sudan, and Somalia, as well as the siege of Sarajevo/Bosnia.

Rainier's photographs have appeared in numerous international publications, including *Life*, *National Geographic*, *Time*, *The New York Times*, *Outside*, *Audubon*, *Conde Nast Traveler*, and publications of both the United Nations and the International Red Cross. His photography is displayed in many major collections around the world, including the Bibliothèque Nationale in Paris, the International Center of Photography in New York City, and George Eastman House in Rochester, New York. From 1980 to 1985, Rainier was a photographic assistant to the late Ansel Adams.

When not photographing, Rainier lectures on photography and its uses as a social tool. He lives among the mountains and streams of Aspen, Colorado.

PAUL BERRY is a television director/producer and a media consultant. He is the author of several books, including *The Essential Self*, a textbook for McGraw-Hill; and *Choices*, a book on contemporary art; and he is the editor of two photography books, *Within a Rainbowed Sea* and *Moloka'i: An Island in Time*. For the past thirty years, Berry has been an instructor of literature, video production, and economics at a prep school in Honolulu.

MARIANNE FULTON is the Chief Curator of the International Museum of Photography at George Eastman House in Rochester, New York. Respected throughout the field as a curator and writer, she wrote essays for *The Wise Silence* photographs by Paul Caponigro and for the Mary Ellen Mark retrospective book, *Mary Ellen Mark: 25 Years*, produced by George Eastman House.

OREN R. LYONS is the "Faithkeeper" of the Six Nations Iroquois Confederacy. One of the most respected elders of the North American Indian tribes, he is also a professor at the University of New York State, Buffalo. Chief Lyons has spoken at many cultural gatherings around the world urging a coming-together of Native peoples and the perpetuation of their cultures.

THE DALAI LAMA is the temporal and spiritual head of Tibet. Enthroned in Lhasa in 1940, he assumed political power in 1950. He fled to Chumbi in South Tibet after resistance to the Chinese in 1950, negotiated an agreement with the Chinese in 1951, and in 1959, fled Tibet for India after Chinese suppression of the Tibetan national uprising. He holds a doctorate in Buddhist philosophy and is the Supreme Head of all Buddhist sects in Tibet. In 1989 he received the Congressional Human Rights award and the Nobel Peace Prize, and in 1991 he received the Freedom Award (U.S.A.). His books include *My Land and People*, *Kindness*, *Clarity and Insight*, and *Freedom in Exile*.

JOAN T. SEAVER KURZE is president of the Easter Island Foundation, a nonprofit group dedicated to preserving the prehistoric and historic culture of Rapa Nui. Dr. Seaver received her Ph.D. in cultural anthropology from UCLA and has served as assistant director for the University of California Research Expedition Program to record rock art on Easter Island.

DAVID SUZUKI is a geneticist and, since 1963, has been an assistant professor at the University of British Columbia. He is a syndicated columnist across Canada and the host of television's *The Nature of Things* on the Discovery Channel and *The Secret of Life* on PBS. He is the author of numerous books, including *Nature in the Home*, *Genethics*, *Inventing the Future*, *It's a Matter of Survival*, *Wisdom of the Elders*, and *Time to Change*.

ERIC CRYSTAL is a professor of anthropology and coordinator for the Center for Southeast Asian Studies at the University of California, Berkeley. His specialty is Indonesian culture and his subspecialty is the culture of Toraja.

DIANA L. ECK is a professor of comparative religion and Indian studies at Harvard. She is the author of *Banaras, City of Light* and *Darsan: Seeing the Divine Image in India*.

ACKNOWLEDGMENTS

I would like to thank the people whose talent, influence, care, and dedication is manifested in this book, though any list of acknowledgments can only end up incomplete. As I witness a dream that began more than a decade ago becoming a reality, I wish to express my gratitude to:

Cindy Black and Richard Cohn, my publishers at Beyond Words. Their commitment to excellence in books sets them apart from the field.

Robin Rickabaugh, whose design efforts are the product of evolution and intuition, the final result being a gesture of refinement.

"Doc" Berry, my writing collaborator and editor, whom I immediately understood to be a man of rare vision and insight.

My photographic friend and assistant Jeff Nixon, a black-and-white printing wizard in a darkroom. Jeff's patient approach to the art of printing has brought incredible depth to many of the prints in this book.

The writers who contributed their excerpts and thoughtful perspectives on the places examined in this book: Diana L. Eck, from *Encountering God: A Spiritual Journey from Bozeman to Banaras*; the elder of the Sepik tribe in New Guinea, who shared his wisdom with me on audiotape; The Dalai Lama, from *The Dalai Lama: A Policy of Kindness*; David Suzuki, from *Wisdom of the Elders*; Joan T. Seaver Kurze, from *A View from the Navel of the World*; Eric Crystal, from an unpublished monograph.

Many individuals and companies who helped me along the way with cameras, film, paper, and darkrooms: Myrick Photo and Russ's Camera of Monterey, California; Oriental Seagull Papers for their generous support; Gary MacGruder of Fuji; Leica Cameras for their generous loan of cameras; and James Baker of Anderson Art Ranch in Colorado.

The numerous people who have supported my travels around the world by giving me assignments and advice: John Parker of Seattle; T. C. Swartz of Private Jet Expeditions; editors of numerous magazines and organizations, including *Outside*; David Friend of *Life*; Peter Howe of *Audubon*; Tom Kennedy of National Geographic Society; Cornell Capa, Miles Barth, and Buzz Harthshorn of International Center of Photography; Robert Stevens and Michele Stevenson of *Time*; Bill Black of *Travel and Holiday*; the International Red Cross; the United Nations; and of course my friends Dana Nelson and Kathleen Klech of *Conde Nast Traveler*.

Many friends whose patience with my absence has taught me lessons of love and support: R. J. Goddard, Alan Harris, Robert Millman, and Pat Sudmeier, who are very much part of this project; Chris Daugherty, who has been an inspiration for many of his friends; Evelyn and Robert Apte, the China-busters; and Elizabeth Rappaport, whose friendship and compassion I cherish. Thanks as well to my friends at Photographers/Aspen, Photo Concern, and J. B. Pictures.

The many writers I have worked with along the way, particularly Tim Cahill, who has shared an adventure or two with me on the untrodden road, and Peter Mathiessen.

My friends David Featherstone and Marianne Fulton, for their support of my photography over the years. Their contributions go beyond help with the text.

A special thanks to Virginia Adams for her friendship and for her support in allowing me to print the photographs in Ansel's darkroom—a place that holds so many fond memories for me.

And finally, a deeply felt thank you to all those who appear in the photographs, the people I have met along the path. To these pilgrims, monks, shamans, and eloquent hobos who have become so much a part of my life, I am deeply indebted.

It is to those seeking that this book really belongs.

Chris Rainier